IMAGES
of America

BELMONT

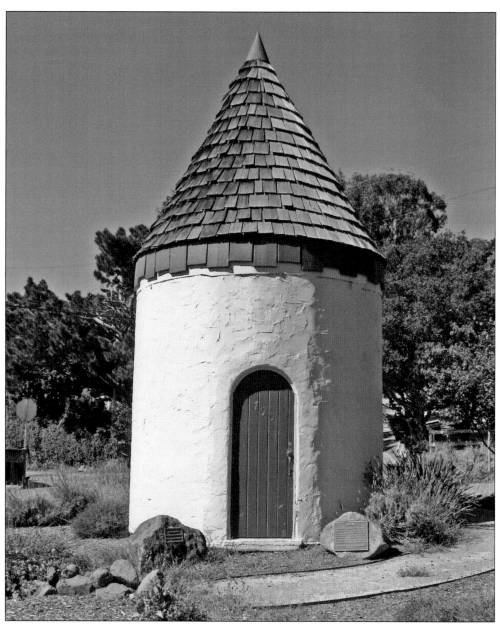

Passersby have long been puzzled by this medieval turret at the three-way intersection of Alameda de las Pulgas, Covington Road, and Arthur Avenue. Belmont Country Club Properties built the structure in 1924 as a sales office for their 1,000-acre development that included the Belle Monti Country Clubhouse across the street, now the Congregational Church of Belmont. (Photograph by Cynthia Karpa McCarthy.)

ON THE COVER: In this c. 1885 photograph, a group of unidentified men, boys, and dogs gather in front of the Emmett Store in the hub on Old County Road. The "Hub of the Peninsula" was Belmont's slogan. Hotels were located across Old County Road and Ralston Avenue from the Emmett Store, and the train station was on the other side of the store, forming the central business district at the time. (Courtesy of Belmont Historical Society.)

IMAGES
of America

BELMONT

To Sara —
We'll miss you here in
Belmont!
Cynthia
July 29, 2022

Cynthia Karpa McCarthy

ARCADIA
PUBLISHING

Published by Arcadia Publishing
Charleston, South Carolina

Printed in the United States of America

Library of Congress Control Number: 2013950321

For all general information, please contact Arcadia Publishing:
Telephone 843-853-2070
Fax 843-853-0044
E-mail sales@arcadiapublishing.com
For customer service and orders:
Toll-Free 1-888-313-2665

Visit us on the Internet at www.arcadiapublishing.com

*To my husband, Ryan, our sons, Jesse and Shane, and to my mother,
Diane Duaine Karpa, who fostered in me a love of history*

CONTENTS

ACKNOWLEDGMENTS

A team effort brought this volume to fruition. I am greatly indebted to the following: Denny Lawhern, Belmont Historical Society president and historian, gave me a key to the society's museum, free rein over images and materials, and answers to my many questions about Belmont's history; Karl Mittelstadt, former Belmont Parks and Recreation director and our next-door neighbor, steadily provided me with introductions, background, and enthusiasm for Belmont history; and the stupendously generous John Shroyer trusted me for weeks at a time with antique photographs and materials of a quality that most archives keep under lock and key. Ryan McCarthy, my husband, a published author and veteran newspaper reporter who grew up in Belmont, provided guidance and encouragement. Our son Jesse McCarthy, a recent honors graduate from the famed history department of the University of California, Santa Barbara, meticulously proofread every draft. Our son Shane McCarthy, a history major at the University of California, Berkeley, joined his father and brother in suggesting better words and phrases.

A heartfelt thanks to the following people and organizations for images and information: the generous Kathleen M. O'Connor, provincial archivist, and Sr. Kay McMullen, volunteer, Sisters of Notre Dame de Namur, Belmont; Debra Kaufman, library reproduction and reference associate, and Mary Morganti, director of library and archives, North Baker Research Room, California Historical Society; Rita Gleason, former Notre Dame Belmont High School principal; Nicholas Meriwether, Grateful Dead archivist, University of California, Santa Cruz; Carol Peterson, archivist, and Alene Kremer, volunteer, San Mateo County Historical Association; and Karen Plesur, associate director of communications, and Denise Winkelstein, director of conferences and advancement events, Notre Dame de Namur University. Belmont residents past and present provided background through the "You know you're from Belmont when . . . " Facebook page. Weekend visitors to the museum shared their recollections, and people like Ernest Malaspina returned my calls and answered my e-mails.

I am deeply grateful to Jeff Ruetsche, the Southwest and West Coast publisher at Arcadia Publishing, who propelled me into writing this book and shepherded it to completion.

Most of the photographs in this book were generously provided by the Belmont Historical Society, founded in 1987 and housed in the historic George Center house in Twin Pines Park. I hope this book complements existing Belmont histories with photographs people have donated to the Belmont Historical Society. There are many more where these came from.

INTRODUCTION

The
Mezes Property
at
BELMONT, SAN MATEO COUNTY, CAL.

is immediately contiguous to the Railroad Station at Belmont, and adjoins
the RALSTON-SHARON Suburban Residence Property.

BEAUTIFUL SUBURBAN RESIDENCES SITES, MAGNIFICENT VIEWS
OF THE BAY, THE CONTRA COSTA HILLS AND THE SANTA CLARA VALLEY.

The Hills to the East afford Protection from the harsh winds and fogs from the Ocean.

Climatic Conditions are Unsurpassed.
Every Feature is Attractive.

WATER IN ABUNDANCE. BEST OF SOIL.
FORTY MINUTES FROM SAN FRANCISCO.
E A S Y T E R M S.

Except for the "easy terms," contemporary Belmont residents would probably agree with the claims made in the 1888 real estate advertisement above. Less than five square miles, Belmont stretches from Belmont Slough on the San Francisco Bay to hilltops overlooking Crystal Springs Reservoir. People have been sold on the town after one drive up tree-lined Ralston Avenue past woodsy Twin Pines Park and stately Notre Dame Belmont High School.

Stories vary on how Belmont got its name—a combination of two words, beautiful and mountain, which some unknown party assigned to the place, according to real estate brochures through the decades. No hill in Belmont reaches the height usually required of a mountain, but people agree it is beautiful, and hikes on some trails can feel like mountain climbing. Silver king William Ralston bought Leonetto Cipriani's country villa in Belmont in the mid-1860s, engulfed the villa, in his mansion and named it "Belmont." Some accounts say he named his grandiose Italianate/Steamboat Gothic mansion—today's Ralston Hall at Notre Dame de Namur University—after a castle in a Shakespearean play, but the first printed mention of the name "Belmont" assigned to our mid-peninsula town was in an 1853 newspaper advertisement.

The first inhabitants were the native Ohlone, who had a seasonal village within current city limits. Twin Pines Park and Davey Glen were two active sites that local history enthusiasts plan to survey more deeply to learn more about the Native Americans. Belmont figured in county

supervisors' plans in 1853 to grade the road from one end of San Francisco County (San Mateo County was formed in 1856) to the other, past the Angelo House, Belmont's landmark near today's Old County Road and Ralston Avenue. The out-of-the-way village halfway between San Francisco and San José would be discovered by more people after Ralston whisked his high-ranking guests from his Palace Hotel in San Francisco to his country estate in a coach.

On a 1922 scouting trip to find a suitably peaceful site for their women's college, the sisters of Notre Dame de Namur walked the hills and valleys of Belmont. One of them, Sister Anthony of the Sacred Heart Quinlan, the author of *In Harvest Fields on Sunset Shores*, described Belmont:

> The wooded hills enclose a lovely little valley with picturesque gorges running on one side toward the calm blue bay, extending on the through the mountains gaps to the broad, bright Pacific. The floor of this beautiful vale, not exceeding four hundred acres, is perfectly flat; from it, the foothills rise, not abruptly, but slope on slope to pine-crested heights of the Coast Range.

The "charming village of Belmont" that 19th-century developers touted has held its own in recent decades as a well-heeled suburb suitable for raising families, but it has not been without its colorful characters and shady goings-on. John McDougall, California's first lieutenant governor and then second governor, moved to Belmont after leaving office disgraced in a dueling scandal in 1852. Once here, he was cited and later acquitted as part of a voting scandal in San Mateo County. A neighborhood and a park bear his name. It might have been a long, strange trip for McDougall to Belmont, but a strong contender in that category is a band of soon-to-be-famous rock and roll musicians recalling how in 1965 they took LSD in La Honda and then drove to Belmont to play in a restaurant bar on Old County Road.

Belmont lost status and land once or twice. When Colonel Cipriani benefited from a change of government in his native Italy and was given the title of count, he sold his Belmont estate to Ralston and left town. Belmont was the first county seat for several months in 1856 until Redwood City claimed the honor. Marine World/Africa USA decamped to Vallejo after nearly 20 years in Belmont, leaving Sterling Downs residents with memories of hearing the animals at night. After more than a century of activity in Belmont Slough—from ferries from O'Neill's Landing to oyster farming and Sea Scouts—Belmont's stake on the bay became part of Redwood City, rebranded as Redwood Shores and home to high-profile corporations such as Oracle and Electronic Arts.

In 1870, almost 60 years before Belmont became a town, 6,635 people called San Mateo County home. The daughter of one of the first American settlers in Belmont, Jane Barre O'Neill Weld, recalled in her 1948 memoir that there were about a dozen houses in Belmont in 1885. In 1970, Belmont's population reached 23,538, and it has remained roughly that size since. After Twin Pines Hospital disbanded in 1972, residents organized to create a park around the historic buildings. The Save Twins Pines Committee helped pass a bond to purchase the George Center manor house that had housed the hospital and the roughly 10 acres of woods, creek, and trails around it. The City of Belmont adopted its first Historic Preservation Ordinance in 1974, largely due to the efforts of the Historic Preservation Committee. The Belmont Historical Society formed in 1987 and two years later created the Belmont History Room in George Center's manor house. In 2009, Belmont made national headlines when the city adopted the country's strictest anti-smoking ordinance, banning smoking in Belmont's 18 city parks, businesses, and multi-unit residences.

History never stops being made. The following photographs tell part of the story of Belmont, "the hub of the peninsula."

—Cynthia Karpa McCarthy
September 2013

One

RANCHO DE LAS PULGAS AT THE CROSSROADS
1795–1863

The Argüello family included California governors and mayors, as well as presidio commandants. In 1795, in the middle of an active career as commanding officer of the Monterey presidio, José Darío Argüello received a grant of over 35,000 acres in what is now San Mateo County. The Argüello family's Rancho de las Pulgas covered present-day San Mateo, Belmont, San Carlos, Redwood City, Atherton, and part of Menlo Park. The land's improbable name—"Ranch of the Fleas"—is thought to recall an early expedition when explorers in Cañada del Diablo woke up with fleas.

When California became a state in 1850, Californios were required to document their titles before a state land commission. The Pulgas Rancho's title was confirmed to Maria Soledad Ortega de Argüello, José Darío's daughter-in-law, and her sons, José Ramón Argüello and Luís Antonio Argüello, in 1856. In a common arrangement at the time, their attorney, Simon Monserrat Mezes, an emigrant from Puerto Rico, netted about 15 percent of the land, or over 5,000 acres, in exchange for his services. Englishman Charles Aubrey Angelo established a hotel of sorts called Angelo's House at the crossroads of Old County Road and Ralston Avenue in the early 1850s. Col. Leonetto Cipriani erected his villa in Belmont in 1853.

San Mateo County was formed out of southern San Francisco County in 1856. When election results that year produced more votes than voters, one resident wrote he was "disgusted and ashamed to own myself a citizen of so young a county so deep in rascality and sin." By May 1859, Mezes was advertising "land for sale or lease on the Pulgas Rancho . . . farming or grazing from 60 acres upwards" and "villa lots 1–5 acres near Belmont" in the *San Mateo County Gazette*. When the San Francisco & San José Railroad connected train tracks from San Francisco to Mayfield just south of Palo Alto in 1863, progress quickly came to "so young a county."

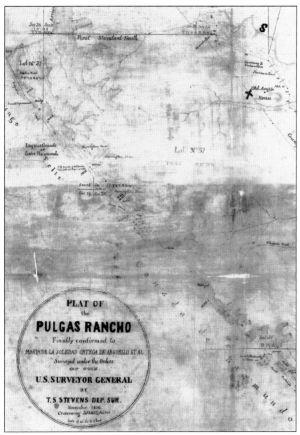

The 1856 map at left shows boundaries of the Rancho de las Pulgas as approved by the US surveyor general. Today, the area covers San Mateo, Belmont, San Carlos, Redwood City, Atherton, and part of Menlo Park. Old Angelo House, the forerunner to Belmont, appears in the upper right-hand corner of the map. An entry in the business directory of the September 6, 1852, edition of the *Daily Alta California* described the establishment as follows: "ANGELO HOUSE, 25 miles from San Francisco, on the road to San José. Private accommodations for ladies and families." The roadhouse was located on the San Francisco–to–San José stagecoach line and at the end of the Half Moon Bay highway, making Belmont an important crossroads. The painter William Dougal, whose painting is below, was a well-known Gold Rush artist. (Both, courtesy of Belmont Historical Society.)

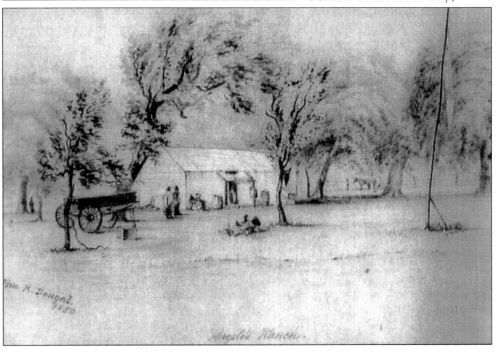

José Darío Argüello was born in New Spain in 1753, founded Los Angeles in 1781, and served as commandant of the San Francisco, Monterey, and Santa Barbara presidios from 1782 to 1806 as well as acting governor of Alta California from 1814 to 1815 and Baja California from 1815 to 1822. He died in Mexico in 1828. San José–based photographer W.W. Wright took this photograph. (Courtesy of California Historical Society, CHS2013.1252.)

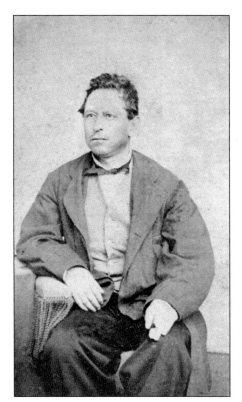

Maria de la Soledad Ortega de Argüello was born in Santa Barbara in 1797 and married Luís Antonio Argüello, José Darío Argüello's son, in 1822. After he died in 1830, she ran Rancho Pulgas and defended the family's claim in the 1850s. She died in Santa Clara in 1874. She was the mother of Luís Antonio Gonzaga Tranquilino Argüello and Ramón Argüello. (Courtesy of California Historical Society, CHS2013.1234.)

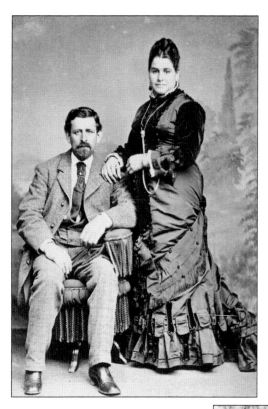

Luís Antonio Gonzaga Tranquilino Argüello (hereafter "Luís AGT"), an heir of the Pulgas Rancho, and his wife, Maria Angela Berryesa de Argüello, are shown in this c. 1877 photograph. Luís was born in San Francisco in 1830 and died in Santa Clara in 1898. He was the son of Luís Antonio Argüello, the first native son to become governor of California. (Courtesy of California Historical Society, CHS2013.1231.)

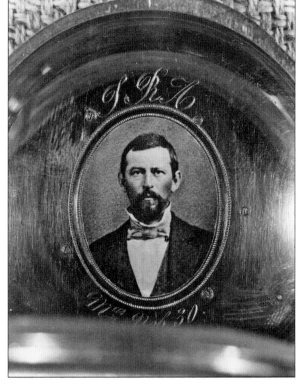

This photograph shows José Ramón Argüello, another heir to the Pulgas Rancho. He was the grandson of José Darío Argüello, son of Luís Antonio and Maria Soledad Ortega de Argüello, and brother of Luís AGT Argüello. He was born in 1828 and died in 1876 in Santa Clara. (Courtesy of California Historical Society, CHS2013.1233.)

New York native David Alonzo Barre (right) arrived in Belmont in the early 1850s and established his ranch in the hills. The *Great Register of San Mateo County, California, 1898* described Barre as 66 years old, with blue eyes, gray hair, and a dark complexion, and as six feet and a quarter-inch tall. A 1912 *San Francisco Call* article the year before he died described Barre as "a wealthy landowner" who owned "a large ranch in the hills near Belmont," some of which is seen in the photograph below. Belmont Canyon Road, now called Ralston Avenue, is visible in the center. On the right, the Belmont School for Boys gymnasium's spire is also visible, meaning the photograph was likely taken in the 1890s. Ralston Mansion is seen on the left at the base of the wooded hill. (Both, courtesy of John Shroyer.)

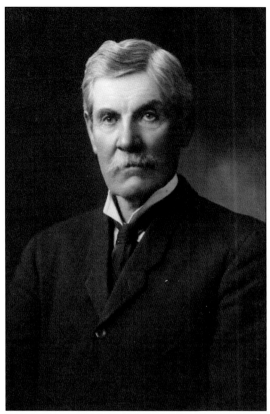

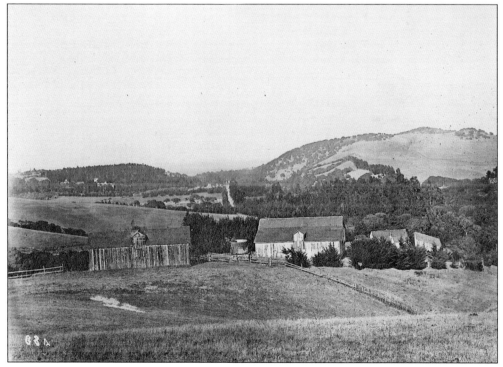

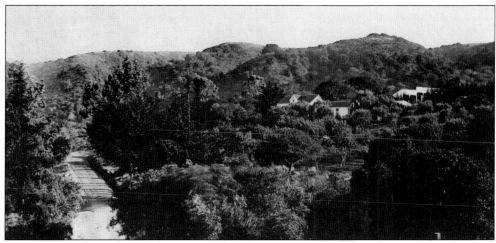

David Alonzo Barre married Katherine Bollinger, daughter of neighboring landowner Christian Bollinger, in 1862. Their children were Charles Norbert Barre, Christopher Columbus Barre, and Ida, Jane, and Mary Barre. The undated photograph below shows the south side of the family's house, probably built the year they married. The three houses his daughters built for their own families remain on the property, near the site of the original house. Their daughter Jane married the son of early Belmont settler Owen O'Neill, a ship's captain who built O'Neill's Landing in the marshes near Belmont and ran freight and passenger boats to San Francisco. The road seen in the photograph above is now known as the road to Water Dog Lake. Early maps show the road as the continuation of Cañada del Raimundo Road, the road going over the mountains. (Both, courtesy of John Shroyer.)

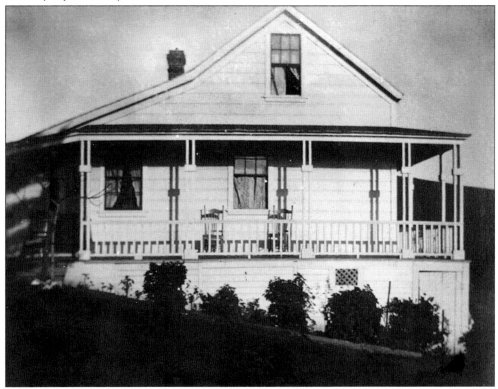

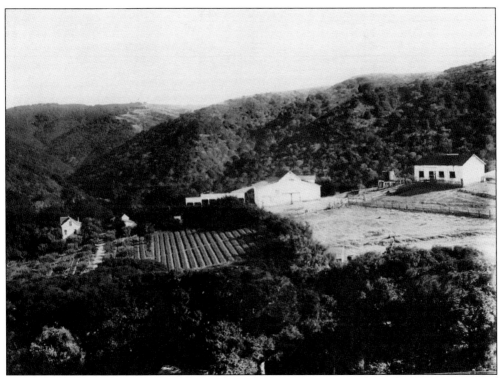

This undated photograph shows a southward view looking from present-day Ralston Avenue toward San Carlos. The Barre house is visible on the left. The barn, stable, water tank, and outbuildings are in the middle and on the right. (Courtesy of John Shroyer.)

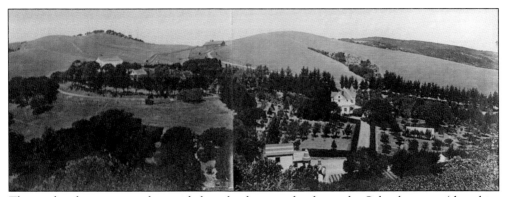

This undated panorama of two side-by-side photographs shows the Splivalo estate (the white house is visible where Merry Moppet Preschool is now) on the right and the Barre ranch in the hills on the left. Apartment complexes and condominiums now cover the hills of the old Barre ranch. (Courtesy of Belmont Historical Society.)

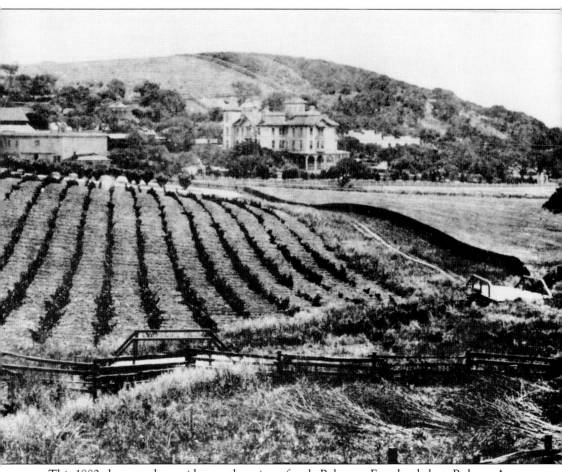

This 1880 photograph provides another view of early Belmont. Farmland abuts Ralston Avenue, with Ralston Hall (see Chapter 3) seen in the background. (Courtesy of Library of Congress.)

Two

THE SF&SJ AND SPRR
1863–1899

In the 1870s, Belmont became a weekend destination for thousands of people. German immigrant Carl Augustus Janke came to California from Hamburg, Germany, and settled in Belmont in 1860. He bought land around Sixth Street and Ralston Avenue, where he built a picnic ground similar to biergartens in his hometown and named it Belmont Park. The site featured a dance hall, a bar, an ice cream parlor, a restaurant, a carousel, platforms in trees, extensive trails through the woods, bridges over creeks, and brass bands.

The San Francisco & San José Railroad formed in 1860. Three years later, one train a day made the round-trip from San Francisco to Mayfield, south of Palo Alto. Coach service from stops in San Mateo and Redwood City brought people to Belmont. Six months later, the SF&SJ connected the two major cities, 50 miles apart. By April 1864, the SF&SJ's advertisements for "moonlight excursion" trains ran in the same newspaper column with advertisements for the Hotel Belmont and Belmont Park, enticing thousands of people from San Francisco and San José to the tiny peninsula village of Belmont. In 1876, Janke opened Belmont Soda Works on Old County Road north of Ralston, allowing him and sons Gus and Charlie to sell their trademark sarsaparillas to travelers stepping off the train to Belmont Park. Later, the Jankes had to add another feature—a jail under the dance floor—to cope with the combination of large crowds and "choice libations." The train company—Southern Pacific Railroad bought SF&SJ in 1870—first posted special police to handle the rowdy crowds. The railroad company stopped running the excursion trains by 1900, when Belmont Park closed. Around the same time, newspapers regularly ran advertisements for automobiles, signaling the start of another era.

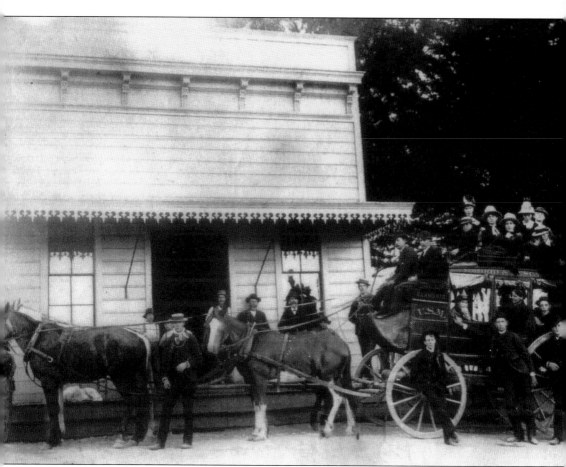

Before train tracks connected San Francisco to San José, stage lines took people and mail to points south, like the Redwood City and Pescadero Stage Co. coach in this undated photograph. The Emmett-O'Neill Store, at the intersection of Old Country Road and Ralston Avenue, was a regular coach stop since the early 1850s. Two early Belmont businessmen, Carl Janke and Henry Carstens, capitalized on Belmont's advantage of being at the eastern end of the shortest route to Half Moon Bay; they established a stage line between Belmont and Half Moon Bay named the Belmont Accommodation Company. General stores often housed the local post office as well, and coaches like this one, emblazoned with "U.S.M." on the side, picked up and delivered mail from villages. One-way fare on coaches traveling from San Francisco to San José was typically about $10. Teachers in the county at the time earned about $50 to $60 a month. (Courtesy of Belmont Historical Society.)

Belmont's first public schoolhouse and its first public library are shown in this undated photograph, taken decades later. In 1859, the first school was established in the home of San Francisco real estate agent Augustus P. Molitor. Accounts place this first public school near today's El Camino Real, north of Ralston Avenue. (Courtesy of Belmont Historical Society.)

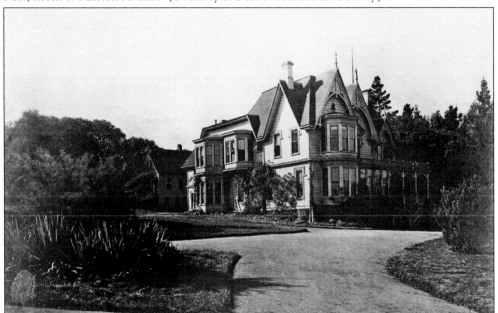

Ralston Cottage, shown in this undated photograph, was first William Ralston's residence, then his Belmont superintendent's residence, and after Ralston's death, a home for his widow and children. In 1885, the Victorian became the Belmont School headmaster's house. Though faculty, men and women, and students formed a bucket brigade to put out a fire, the house was destroyed in October 1908. (Courtesy of Belmont Historical Society.)

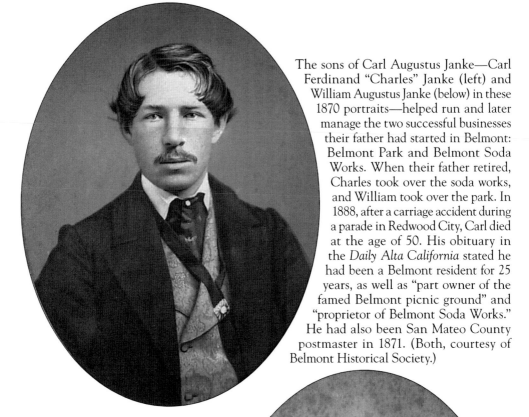

The sons of Carl Augustus Janke—Carl Ferdinand "Charles" Janke (left) and William Augustus Janke (below) in these 1870 portraits—helped run and later manage the two successful businesses their father had started in Belmont: Belmont Park and Belmont Soda Works. When their father retired, Charles took over the soda works, and William took over the park. In 1888, after a carriage accident during a parade in Redwood City, Carl died at the age of 50. His obituary in the *Daily Alta California* stated he had been a Belmont resident for 25 years, as well as "part owner of the famed Belmont picnic ground" and "proprietor of Belmont Soda Works." He had also been San Mateo County postmaster in 1871. (Both, courtesy of Belmont Historical Society.)

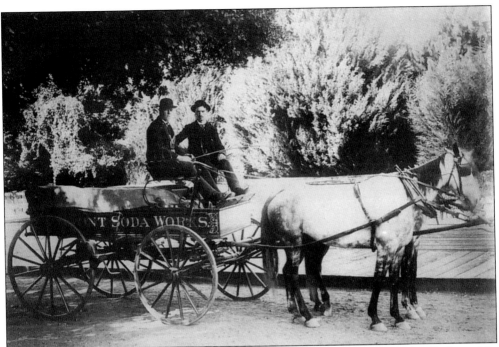

In 1876, Carl Janke opened Belmont Soda Works along Old County Road, north of Ralston. His sons, Gus and Charles, operated the soda works together for a time. With the soda works near the train depot, the Janke brothers sold sarsaparilla to people getting off the train to Belmont Park, also operated by the Jankes. Thousands traveled to the popular Belmont Park via special excursion trains (below), which also stopped in San Mateo, Belmont, Redwood City, Santa Clara, and San José. As a result, the mid-peninsula village's profile was raised to a level on par with bigger towns. (Both, courtesy of Belmont Historical Society.)

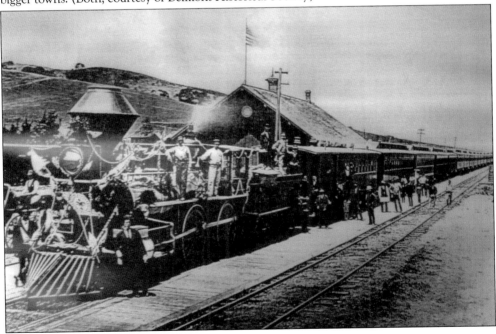

In April 1864, Carl Janke advertised Belmont Park, shown in this photograph, in glowing terms: "THE PUBLIC WHO WISH TO spend a few hours pleasantly, are invited to visit BELMONT PARK, located in a BEAUTIFUL GROVE at the entrance of Canon Diablo . . . about 300 yards from the Depot at Belmont. The Proprietor, MR. C. Janke, is a German, also proprietor of Turn-Verein Hall, San Francisco, having had many years experience in beautifying places of amusement, feels confident that this PARK is more attractive than any other place in California." (Courtesy of Belmont Historical Society.)

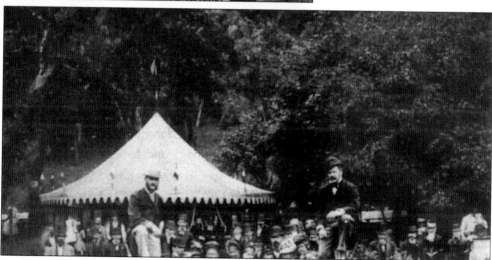

In addition to a large dance hall, the 30-acre park featured a "bar well supplied with choice liquors," "music for dancing," and a "very large oak tree, near a fine stream of water, surrounded by large oaks and shrubbery, with winding stairs up and platforms in many of the trees." (Courtesy of Belmont Historical Society.)

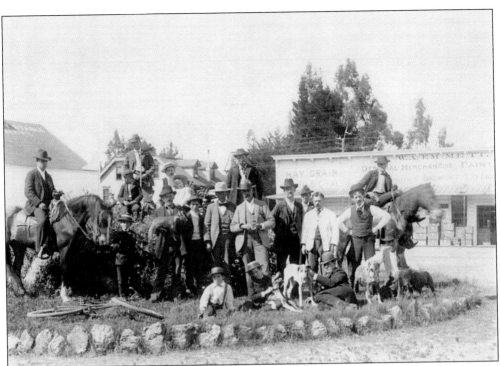

Men and boys, members of a hunting club, returning from a fox hunt stand in the "hub" behind the W.A. Emmett General Merchandise Store on Old County Road in the late 1880s. Englishman Walter Alfred Emmett bought property in Belmont in 1881 and ran the Emmett and O'Neill General Merchandise Store with partner Matt O'Neill until he bought out O'Neill in 1889. The store (below), which also housed the post office, was located across from the train station on El Camino Real. Emmett ran the store until he retired in 1909. Both men have downtown Belmont streets named after them. (Both, courtesy of Belmont Historical Society.)

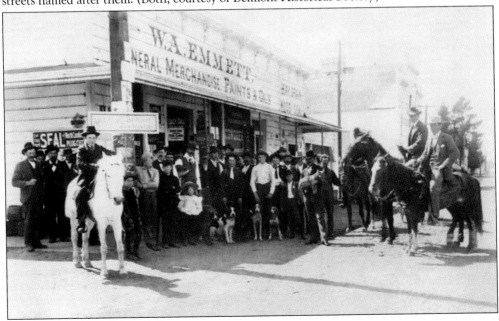

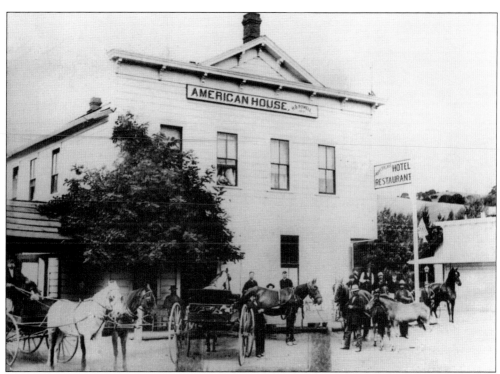

In the 1870s, the American House hotel (above) stood adjacent to the railroad tracks on the southwest corner of Ralston Avenue and Old County Road. Siblings Jack and Elizabeth "Lizzie" Rowell owned the 14-room hotel and bar constructed in late 1884. Across the street, on the northwest corner, was another hotel owned by Constable H.C. Caldwell. Elizabeth and Jack (below) stand at the hotel's billiard table. The hotel remained in the Rowell family for over 60 years. (Above, courtesy of Belmont Historical Society; below, courtesy of San Mateo County Historical Association.)

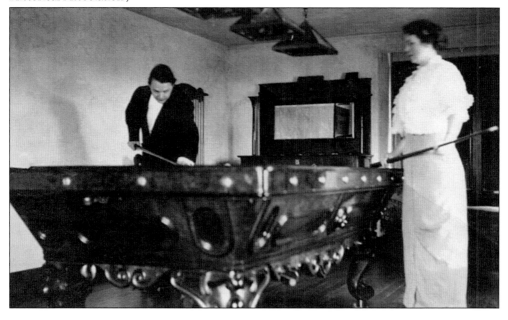

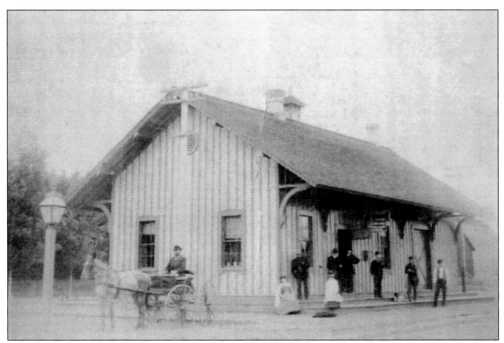

A year before this 1876 photograph of the train depot was taken, the 1875 directory of San Mateo County described Belmont as "quite an enterprising little business place," writing that the village "possesses many attractions . . . comprises within its limits, a hotel, store and saloon, a feed and livery stable and several residences." (Courtesy of Belmont Historical Society.)

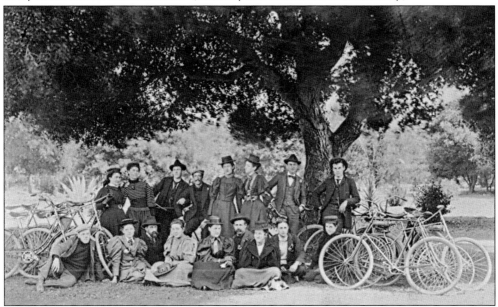

This group, identified by surnames only, recorded their bicycle trip to Belmont in this photograph dated April 17, 1896. In unknown order are Mssrs. Dunstan and Brooks, Miss Rawdon, Mssrs. Snow and Hopkins, Misses Mount and Swanson, Miss Clark, Mr. Hatch, Miss Mount, Mr. Cuthbertson, Misses Gould and Parker, Mr. Emery, Miss Brown, and Mr. Snow. (Courtesy of Belmont Historical Society.)

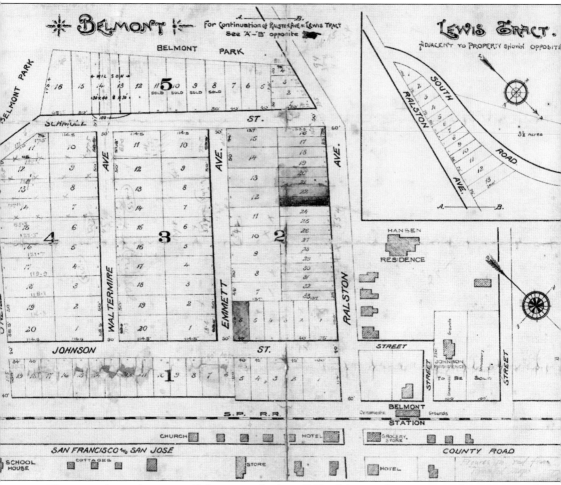

This map shows downtown Belmont in the late 1880s. Johnson Street was used to connect El Camino Real through Belmont. The train station remains in the same place today. Schmoll Street, toward the top, is now Sixth Avenue. Waltermire and Emmett Avenues, named after an early-day hotelier and a general store proprietor, now bound the Safeway grocery store and its parking lot. The lots labeled "1" are now the CalTrans parking lot, where the farmers' market is held. The early commercial district is centered on County Road and Ralston Avenue. The site of the Emmett Store is labeled "Grocery Store," and the "Hotel" across the street was the American House, operated by the Rowell family, which stood at the southwest corner of Old County Road and Ralston Avenue. The church on the map was the Church of the Good Shepherd, now on Fifth Avenue. (Courtesy of San Mateo County Historical Association.)

This c. 1895 photograph shows the road from the Belmont School for Boys, where Immaculate Heart of Mary Church and School now stands, to the center of town about a mile away. The crossroads of Old County Road and Ralston Avenue formed a central business district, including the train depot, the Emmett Store, and the American House hotel. (Courtesy of John Shroyer.)

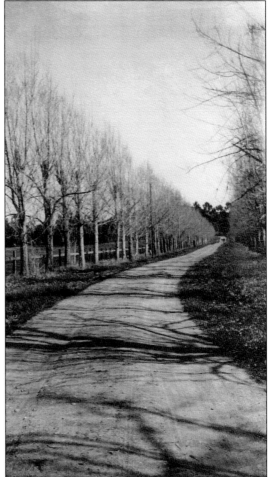

Walter Alfred Emmett and Matt O'Neill bought the business pictured below from Carl Janke in 1880; then in 1884, the pair also purchased the property. O'Neill was postmaster in 1887, the same year San Mateo County sued both men over "the validity of" their liquor license. Fortunately, they were able to produce a receipt showing they had paid $75. In 1889, Emmett bought out the O'Neill partnership. (Courtesy of Belmont Historical Society.)

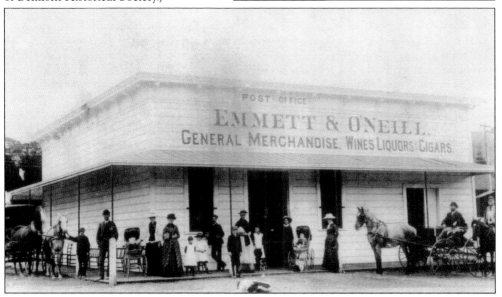

These two undated photographs depict a quiet country life some distance away from Belmont proper. Handwritten notes on the back refer to the small house as "Wayside Cottage" and relate the following message: "Uncle Frank Blackburn took this picture, probably in the late 1880s. Old house on road from school to San Carlos I think. I remember it and always was charmed by it even as a little girl so never have forgotten it. H. T." Uncle Frank was likely Francis A. Blackburn, a principal of the Boys' High School in San Francisco in the mid-1880s before leaving to take a post at the Belmont School for Boys. The "road from school to San Carlos" was Alameda de las Pulgas. (Both, courtesy of John Shroyer.)

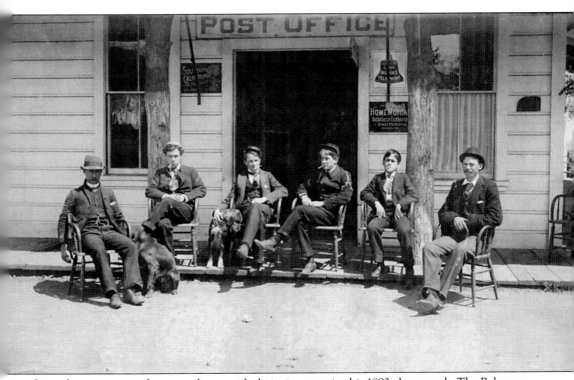

Several young men strike a casual pose with their cigarettes in this 1893 photograph. The Belmont Post Office was located in the Emmett Store at this time, which was handy because of its proximity to Old County Road and the train tracks. (Courtesy of Belmont Historical Society.)

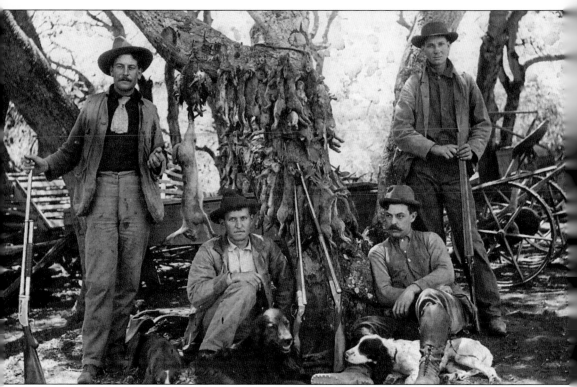

By 1900, Belmont was rural but connected to cities by railroad and to the coast by stagecoach. This 1898 photograph taken on the Barre ranch shows Christopher Columbus Barre, Christopher Norbert Barre, S.A. Sharp, and G. Franzen (their order unknown) after a rabbit-hunting foray. Today, hikers on Water Dog Lake Trail can attest that Belmont Canyon still teems with rabbits. (Courtesy of John Shroyer.)

Three

THE WHITE HOUSE
OF THE WEST
1865–1875

Dubbed "the man who built San Francisco," William Chapman Ralston chose Belmont for his country estate. Ohio-born Ralston made his fortune in Nevada's Comstock Lode, the massive silver deposit discovered in 1859, and founded the Bank of California in 1864. Ralston bought a villa that Count Leonetto Cipriani had built in Italy, dismantled, packed in boxes, shipped to California, and reconstructed in a pastoral setting with more sunshine than San Francisco. Ralston subsumed the two-story structure into the grand peninsula mansion he made famous.

Ralston entertained so many VIPs of the day, including Gen. Ulysses S. Grant and later Grant's vice president, Schuyler Colfax, that he earned Ralston Hall the nickname "the White House of the West." The property included stables for the horses that, according to fellow financier and probable guest J.A. Graves in his 1928 memoir, *My Seventy Years in California: 1857–1927*, he rode to race the train to and from "San Francisco daily, with relays of double teams." Ralston later used features from his four-story, 55,000-square-foot Italianate Belmont mansion in his extravagant Palace Hotel in San Francisco.

Ralston drowned in 1875 during a routine swim in the San Francisco Bay the day his bank failed, leading people to wonder whether his death was suicide. His business partner, Sen. William Sharon, then acquired Ralston Hall and the Palace Hotel. Ralston's widow and children moved to Little Belmont, a two-story Victorian Ralston had built a mile away.

After Sharon's death in 1885, the hall housed the Radcliffe School for Girls. When the superintendent of an asylum bought the estate to open a sanitarium in 1900, the *San Francisco Call* ran the headline "Ralston's Belmont Palace Will Become a Madhouse." When the Sisters of Notre Dame de Namur bought the estate in 1922 for their College of Notre Dame, the hall was "in a sad state of sad degeneration" that "resembled a white lily trampled in mire; a pallid corpse without a soul," as recorded in *In Harvest Fields by Sunset Shores*. Now the site of university offices as well as a popular wedding venue, Ralston Hall was made a National Historic Landmark in 1966.

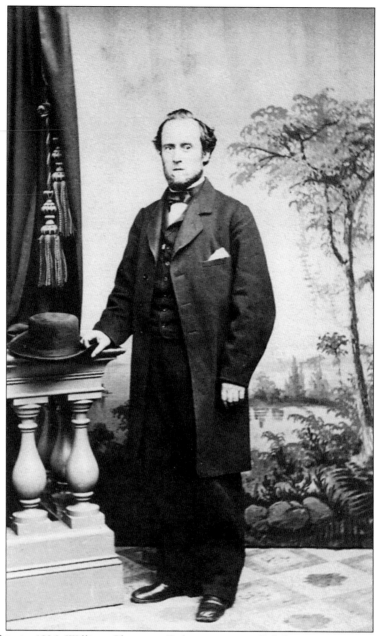

Born in Ohio in 1826, William Chapman Ralston came to California in 1849 as a steamboat captain, bringing gold-seeking '49ers up the West Coast from Panama. A few years later, Ralston settled in San Francisco and, in 1864, opened the Bank of California, lending money to companies mining silver in Nevada after the Comstock Lode was discovered in 1859. When owners defaulted on his loans, Ralston kept their mines, becoming one of the Bonanza kings and garnering enough wealth to earn the nickname "the man who built San Francisco." Ralston was known for his civic generosity as much as his aggressive business dealings. This portrait of Ralston was taken about 1865 in the San Francisco photography studio of William Shew at 423 Montgomery Street, five blocks from the extravagant Palace Hotel that Ralston built on New Montgomery Street. But first, he had created "the White House of the West" in Belmont. (Courtesy of John Shroyer.)

These portraits of William Chapman Ralston were likely taken during one sitting, as he appears to be wearing the same suit. Both were taken by Bradley & Rulufso on Montgomery Street in San Francisco, not too far from Ralston's Palace Hotel on New Montgomery Street. The photographer's emblem on the back includes the date of a gold medal he won in Vienna in 1873. Ralston died in 1875 by drowning in the San Francisco Bay the day his bank collapsed, raising questions about his death. Of Scotch-Irish descent, Ralston's funeral was held in Calvary Presbyterian Church off Union Square in San Francisco, while thousands lined the streets. (Right, courtesy of Belmont Historical Society; below, courtesy of John Shroyer.)

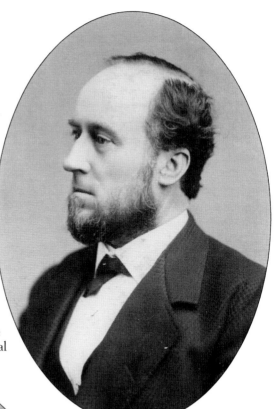

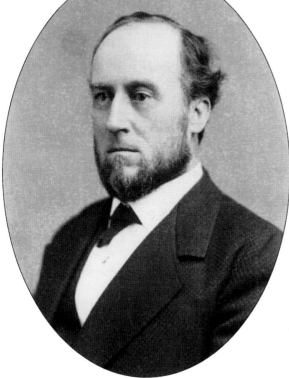

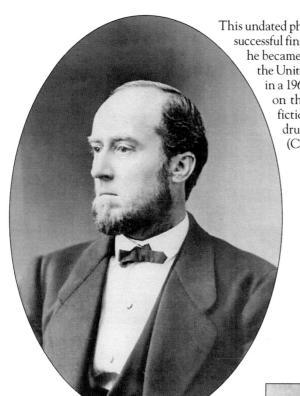

This undated photograph of William Ralston shows the successful financier at the height of his success. Before he became governor of California and president of the United States, Ronald Reagan played Ralston in a 1965 *Death Valley Days* episode, titled "Raid on the San Francisco Mint," in which the fictional Ralston got the head of the mint drunk so he could trade bullion for coins. (Courtesy of John Shroyer.)

In San Francisco in 1858, William Ralston married Elizabeth "Lizzie" Fry, who would become the mother of his five children: Samuel Fry Ralston, born in 1859; Etna Louise, born in 1860 and died in 1862; William Chapman Ralston, born in 1863; Emelita Thorn Ralston Page, born in 1865; and Bertha Ralston Bright, born in 1872. Elizabeth was not as enthusiastic about Belmont as William. (Courtesy of Belmont Historical Society.)

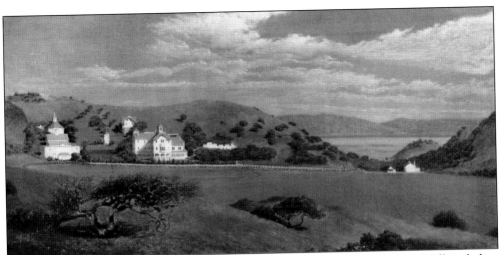

Massachusetts-born painter Charles Albert Frost created this early work of Ralston Hall, including the stables and outbuildings of the 14-acre estate. Ralston took three years to expand Count Cipriani's two-story villa into the mansion pictured here. In his memoirs, Cipriani described the estate as his "elegant prefabricated home in Belmont, the first of consequence on the peninsula, later to become The Ralston Mansion." (Courtesy of Belmont Historical Society.)

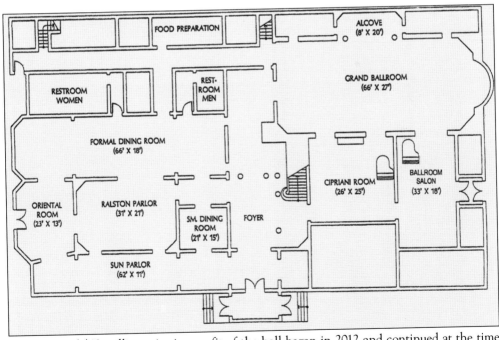

An estimated $12-million seismic retrofit of the hall began in 2012 and continued at the time of this book's writing a year later. The front sun parlor is a veranda enclosed with windows that resembles the promenades of steamboats Ralston had captained. The alcove in the ballroom was designed to house musicians performing at Ralston's many parties. (Courtesy of Notre Dame de Namur University.)

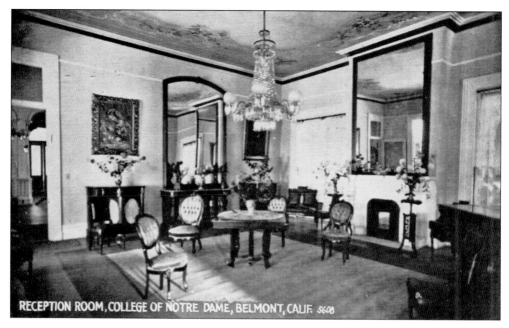

RECEPTION ROOM, COLLEGE OF NOTRE DAME, BELMONT, CALIF. 5608

Most postcards over the years have featured Belmont's showpiece, Ralston Hall. This reception room (above) welcomed many illustrious people in the little more than a decade that William Ralston owned the estate. In the floor plan, this room is called the Cipriani Room, after Leonetto Cipriani, the prior owner of the property. Cipriani built his villa in Italy in 1852, then had it dismantled and shipped it, at reportedly 120 tons, to Belmont. Many have marveled at the mirrored ballroom (below), modeled after the Hall of Mirrors in the Palace of Versailles, France. Mirrors are one of the features Ralston used again in the building of San Francisco's Palace Hotel. (Both, courtesy of Denny Lawhern.)

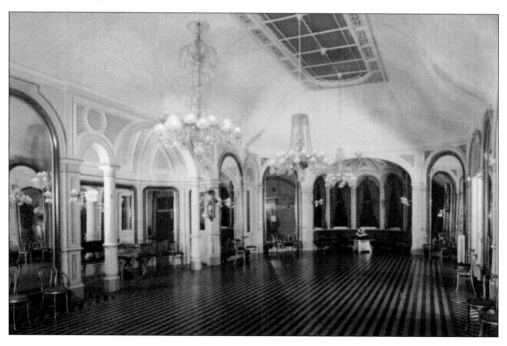

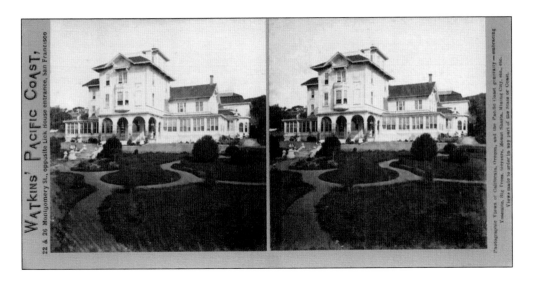

Carleton E. Watkins, a San Francisco photographer and publisher, created most of these double images, called stereographs. Watkins was probably hired by Ralston to record his mansion, as seen in the view below. Each card includes the following advertisement: "Watkins' Pacific Coast, 22 & 26 Montgomery St., opposite Lick House Entrance, San Francisco," and "Photographic Views of California, Oregon, and the Pacific Coast generally—embracing Yosemite, Big Trees, Geysers, Mount Shasta, Mining City, etc., etc. Views made to order in any part of the State or Coast." Watkins lost his gallery and all his negatives after the 1875 banking crisis, possibly caused by Ralston's bank failure. Writing on the back of the stereograph above of Ralston Hall's north side details this view as "Looking down from Guest-house." Cuvilly Hall is at the top of the stairs pictured below. (Both, courtesy of John Shroyer.)

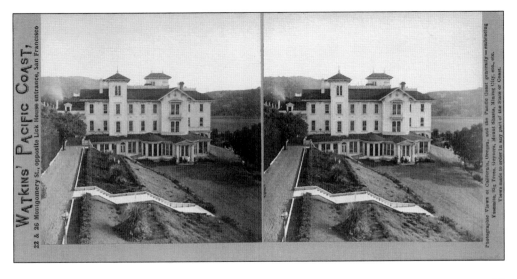

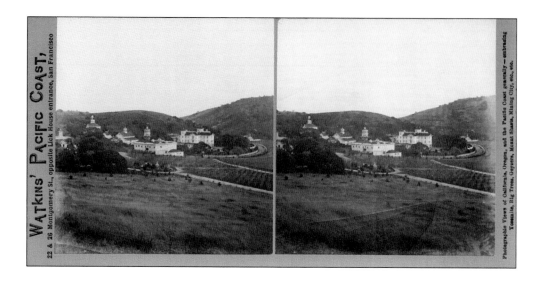

WATKINS' PACIFIC COAST, 22 & 26 Montgomery St., opposite Lick House entrance, San Francisco

Photographic Views of California, Oregon, and the Pacific Coast generally — embracing Yosemite, Big Trees, Geysers, Mount Shasta, Mining City, etc., etc.

Off in the distance, many of the outbuildings on the Ralston estate are visible. The fields in the foreground of the image above appear to be planted in grapes, which is not surprising since Ralston dabbled in wine making and the mansion had a wine cellar below the first floor. Ralston was a strong supporter of Hungarian refugee Agoston Haraszthy, a pioneer in the California wine industry whose vineyards still operate today in Sonoma County. The north side of Ralston Hall is shown in the stereograph below. (Both, courtesy of John Shroyer.)

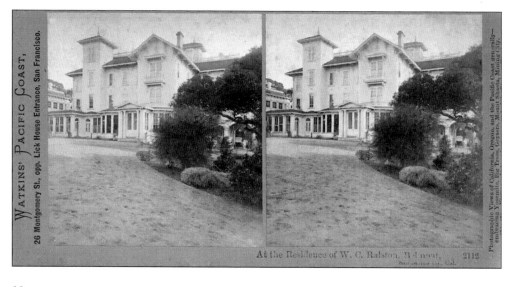

WATKINS' PACIFIC COAST, 26 Montgomery St., opp. Lick House Entrance, San Francisco.

Photographic Views of California, Oregon, and the Pacific Coast generally — embracing Yosemite, Big Trees, Geysers, Mount Shasta, Mining City.

At the Residence of W. C. Ralston, Belmont, 2112

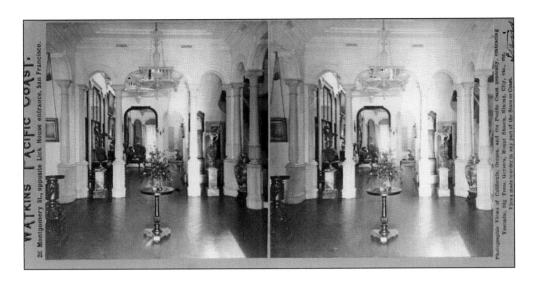

The photograph for this postcard of the entry below, described as a vestibule, was taken after the Sisters of Notre Dame de Namur's purchase of the estate in 1922. The earlier Watkins stereograph above was taken from just a few steps into the hall. Both images show as impressive an entrance as Ralston's thousands of guests must have seen it. Newspaper accounts of the day describe both the house and Ralston's parties as "lavish," "sumptuous," and "extravagant." (Above, courtesy of John Shroyer; below, courtesy of Denny Lawhern.)

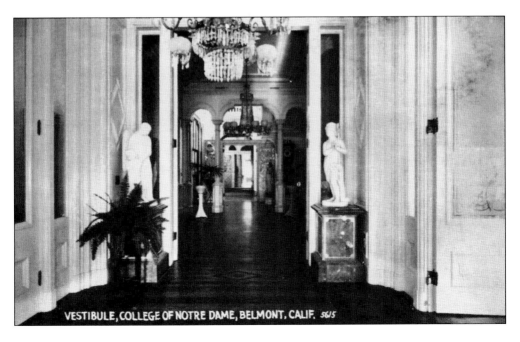

VESTIBULE, COLLEGE OF NOTRE DAME, BELMONT, CALIF. 5615

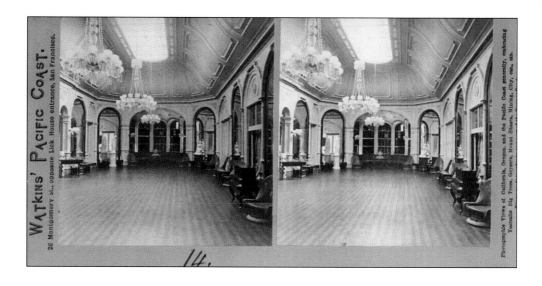

These two views of Ralston Hall's legendary ballroom, considered the showpiece of the estate, feature some of the mansion's French crystal chandeliers and walls lined with mirrors, as well as a bay window looking out on the garden. The arches in the ballroom were the inspiration for those adorning the lobby of the Palace Hotel in San Francisco, as were the ballroom's mirrors, which were incorporated into the hotel's Garden Court restaurant. Ralston used many of the architectural details found in his Belmont mansion, including the skylight, in the Palace Hotel on New Montgomery Street in San Francisco. (Both, courtesy of John Shroyer.)

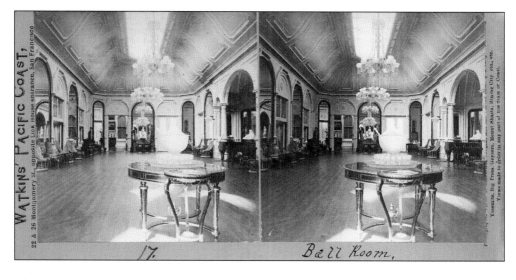

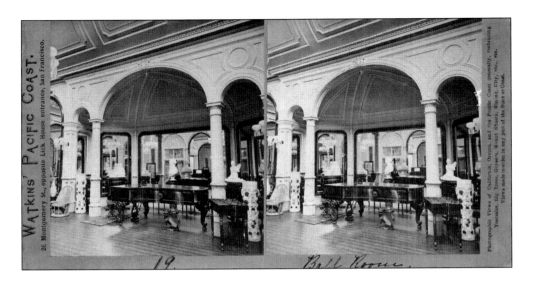

The musicians' alcove, shown in the stereograph above, and the statues reflected in mirrors, shown in the one below, recall the grand ballroom's glory days, when Leland Stanford and Mark Hopkins attended parties here. Ralston built his own gasworks at a cost of more than $50,000 just to light the dozens of chandeliers. Alternating cedar and black walnut boards bordered by mahogany create a chevron border around the ballroom floor and diamonds in other rooms' floors. (Both, courtesy of John Shroyer.)

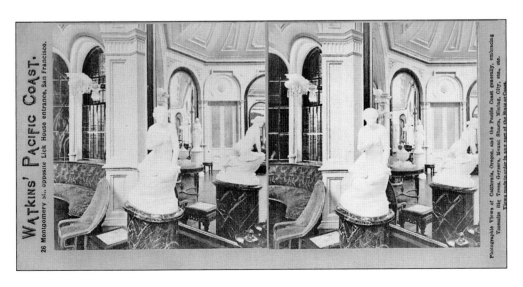

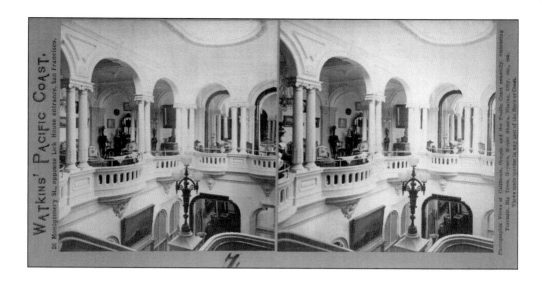

Six opera boxes line the mezzanine at the top of the grand staircase, an idea Lizzie Ralston borrowed from an opera house in Paris. After Ralston's death, his former business partner, Sen. William Sharon of Nevada, moved in with his family. His daughter Flora's wedding to Sir Thomas George Fermor-Hesketh, seventh Baronet of Rufford, was held in the ballroom, one of the last elaborate social events of the time. Ralston used parties at his elegant mansion to court investors for his Bank of California. (Both, courtesy of John Shroyer.)

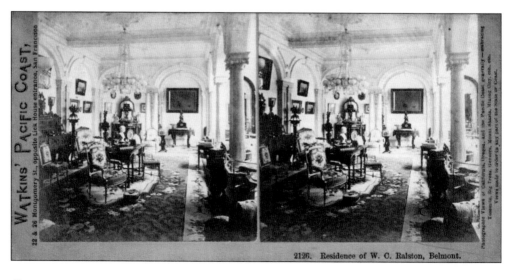

2126. Residence of W. C. Ralston, Belmont.

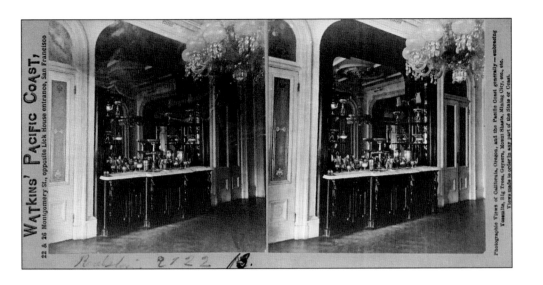

These views echo the following account published in the *San Francisco Call* (Volume 87, Number 85) on August 24, 1900, which was 25 years after Ralston's death: "The house Is, perhaps, the most famous private palace on the Pacific Coast. In the olden days it was the scene of oriental luxury and the rooms that will now echo to the riot of madness sounded once to the revelry and mirth and gayety of wild spirits called together by the fabulously wealthy owner, who lavished fortunes in caprice and indulged the wildest fancies of extravagance. In the days of its decadence the palace became a young ladies' seminary. The revelry that once ruled it lived only in memory and now In tragic climax it will become the home of spirits unbalanced by the madness of grief and not of joy." (Both, courtesy of John Shroyer.)

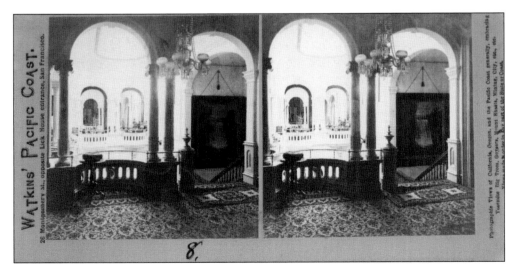

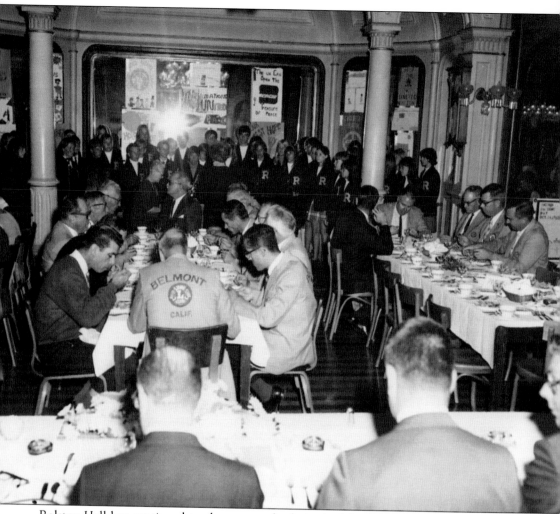

Ralston Hall has continued to play a central role in the life of the community. This c. 1970 photograph shows Ralston School students performing in the musicians' alcove during a Lions Club meeting. Cipriani established his estate in Belmont in the 1850s, saying in his memoir, "Out there it [the estate] is considered magnificent." Once he was made a count, he sold his estate to Ralston and returned to Italy. Ralston took three years to build his showplace around Cipriani's villa, later described as "modest" by comparison. The Ralstons lived there for about a decade, followed by Ralston's surviving business partner, William Sharon, and his family the following decade. The widow of a business associate of Ralston's ran Radcliffe School out of the mansion for a few years before Dr. Gardner's Sanitarium for Nervous Disorders opened there in 1900. The Sisters of Notre Dame de Namur have owned Ralston Hall since 1922. Newell Sharkey photographed many civic events in Belmont, like this one in the 1960s and 1970s, working out of his studio on Laurel Street in San Carlos. (Courtesy of Belmont Historical Society.)

Four

A HEALTHFUL CLIMATE, A VAST SOLITUDE
1885–1950

Belmont's distance from cities and its sunnier-than-San Francisco climate drew both educators and doctors early on. Over decades, the "hub of the peninsula" has been home to a prestigious boys' preparatory school, California's first college to grant degrees to women, and several sanitariums treating either tuberculosis or psychiatric disorders. A Sister of Notre Dame de Namur rhapsodized about Belmont's "vast solitude."

Advertisements for sanitariums raved about Belmont's "healthful climate." San Mateo County's 1929 telephone directory listed the Alexander, California, M.C. Reed, and Twin Pines Sanitariums on "Ralston Road," and stories of escapes, confinements, and unexplained deaths regularly made the newspapers.

Some structures did double duty. After Comstock king William Ralston died in 1875, Ralston Hall housed a girls' seminary for a few years, a sanitarium for nervous disorders for about 20 years, and finally, the College of Notre Dame, now the Notre Dame de Namur University, since 1923.

The Belmont School for Boys opened in 1885 near Alameda de las Pulgas and Ralston Avenue, an area the school's catalog described as "while possessing nothing of grandeur, has singularly varied elements of beauty, fitted to excite a wholesome love of nature." Its 1899 booklet touted Belmont's "initial advantages of retirement, without the disadvantages of isolation," noting that "the SPRR [Southern Pacific Railroad] station is a mile and a quarter from the school and San Francisco an hour's train ride away."

As San José grew, the sisters sought a quieter setting, eventually settling on Belmont's Ralston Hall, about which college dean Sr. Anthony Quinlan wrote the following: "We walked for an hour or more through absolute solitude with miles and miles of rolling land visible without one habitation of any kind so that we might have easily imagined we were in the midst of a vast solitude far removed from any vestige of civilization. We remarked it would be years and years before this wide solitude would be disturbed for it seemed almost impossible that the lands could in any way be connected with the towns along the highway." So it seemed in 1922.

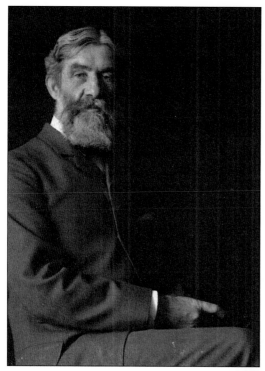

Former University of California president William T. Reid (left) opened the Belmont School for Boys in 1885 on property southwest of the present-day intersection of Ralston Avenue and Alameda de las Pulgas. Below, Reid stands on the right, probably with his faculty, on the stairs of Little Belmont, the house Ralston built for his Belmont superintendent. Faculty included graduates of Harvard (like Reid), Yale, and Stanford Universities; Occidental, Middlebury, and Hamilton Colleges; and San Jose Normal School (now San José State University). Tuition was $750 per year for the "lower school" and $900 a year for the "upper school." When the Belmont School for Boys opened on August 5, 1885, there was room for only 25 students at Little Belmont. (Left, courtesy of John Shroyer; below, courtesy of Belmont Historical Society.)

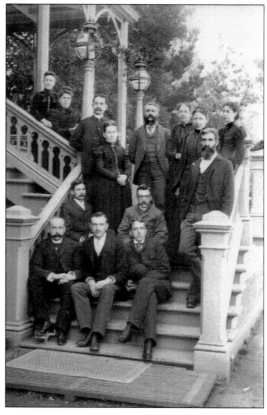

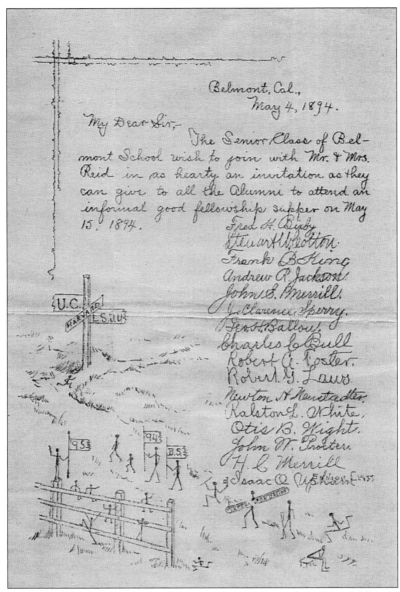

Dated May 4, 1894, this invitation to an alumnus to attend "an informal good fellowship supper" depicts Belmont School graduates going off to University of California, Harvard, and Leland Stanford Junior University (LSJU). According to the school's annual program for 1897–1898, the Belmont School was "Not a School for Short Cuts" and would not "undertake to do hasty or Ill-digested work." Graduates from 1895 to 1915 entered University of California, Stanford, Harvard, Massachusetts Institute of Technology, Yale, Amherst, Rensselaer Polytechnic Institute, University of Southern California, Cornell, University of Virginia, Wellesley, Michigan, Wisconsin, University of Pennsylvania, Washington, and Pomona. Reid's daughter, Julia Frances Reid, apparently an 1889 graduate of Belmont School for Boys, went to Wellesley College. The Belmont School merged with another private school, Hopkins Academy, in 1893, and the two schools were incorporated as Belmont School, W.T. Reid Foundation. Reid ran the school until August 1918, when the Most Reverend Edward J. Hanna, archbishop of San Francisco, purchased it to open St. Joseph Military School, which closed in 1952. (Courtesy of Belmont Historical Society.)

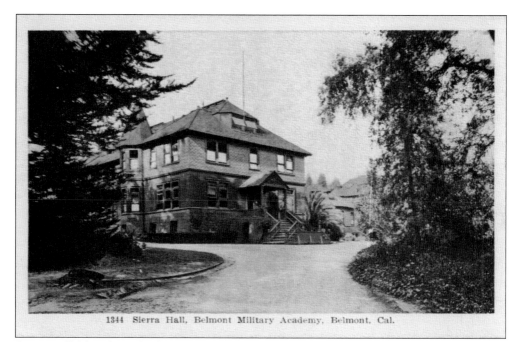

1344 Sierra Hall, Belmont Military Academy, Belmont, Cal.

Sierra Hall (above) was built in 1891. When the Belmont School for Boys became St. Joseph's Military Academy in 1932, the name of Sierra Hall was changed to St. James Hall. "Class Day Guests" reads the printed caption on the front of this postcard (below), mailed in 1923 and postmarked in Belmont. By the time this postcard was sent, William Reid had been retired for five years, and his son William Reid Jr. had taken over running the school. On September 7, 1918, Reid Sr. sent a telegram from Cohasset, Massachusetts, "giving up ownership" of the school. His wife, Julia Reid, died the year before, not very long after she had readied the invitations for Class Day, the event depicted in the postcard below. (Both, courtesy of Denny Lawhern.)

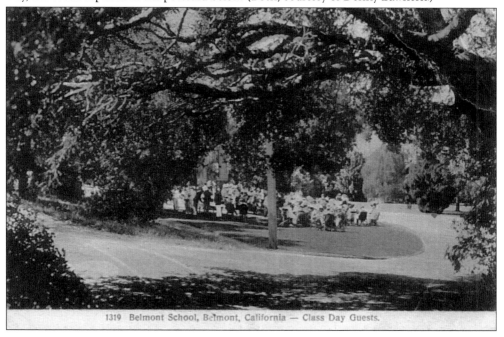

1319 Belmont School, Belmont, California — Class Day Guests.

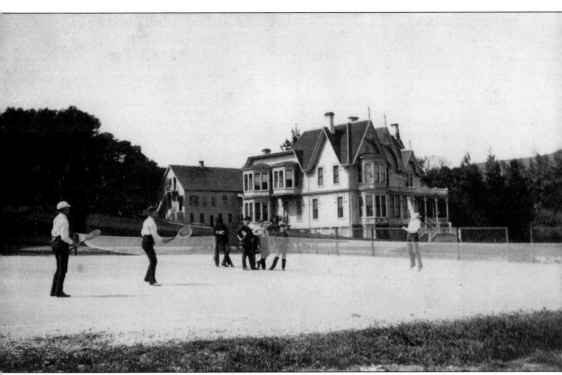

Belmont School for Boys headmaster William Reid vowed to build athletic facilities to rival regional schools, including Stanford University. Evidence of that vow includes badminton courts the students pictured above used. Little Belmont, formerly William Ralston's home and then the headmaster's house, is seen in the background. Students lived in Little Belmont when the school first opened in 1885 until dormitories were built, one of which can be seen behind the large Victorian. The Belmont School represented an early building boom and was considered on the outskirts of Belmont on its site at Ralston Avenue and Alameda de las Pulgas. (Courtesy of John Shroyer.)

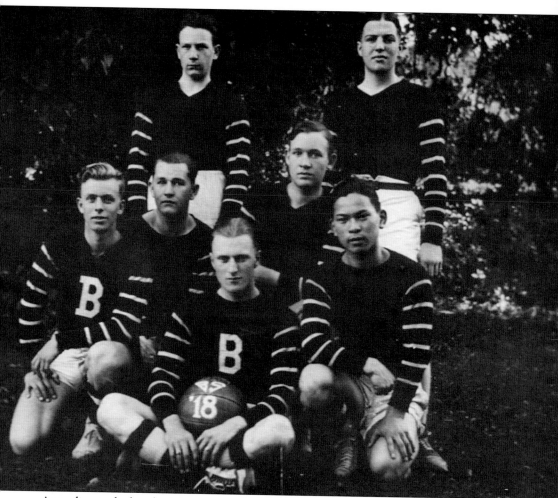

According to the handwritten note on the back of this photograph, the Belmont School for Boys basketball team of 1918 included, from left to right, (first row) Donald Thompson, Herbert Joyce, and Takeo Domoto; (second row) Iver Iverson and Henry Carten (probably of Sausalito); (third row) Wilford Darneal Wetzel (of King City) and James Wordon Roberts (of Spokane, Washington). The school also had a "swimming tank," connected to the gym by a covered corridor. Known as the Belameda Pool, this facility was used by the community until 1976. (Courtesy of John Shroyer.)

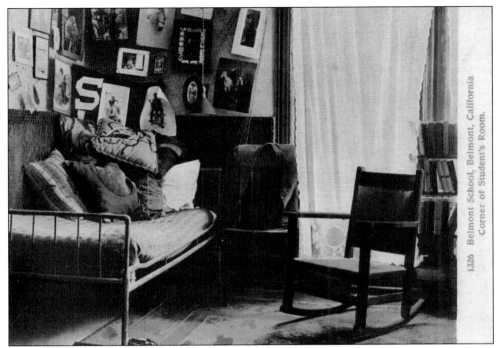

This image, titled "Corner of Student's Room" at the Belmont School for Boys, was likely taken in Little Belmont, a Victorian house William Ralston built about a mile from Ralston Hall for the superintendent of his Belmont estate and where Ralston's widow and children moved after his death in 1875. At age 21, California writer Jack London "put aside his pencils and found a job in the laundry of the Belmont Academy" in 1897, according to an account by writer Irving Stone. (Both, courtesy of Denny Lawhern.)

1313 Belmont School, Belmont, California — Teachers' Bridge.

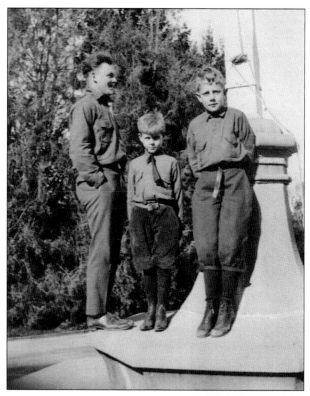

At left, an upper school student joins two lower school Belmont boys on the flagpole base. According to a school catalog, military drills, "supplemented by the West Point setting-up exercises," were part of the curriculum, and students were expected to arrive in uniform at the noontime meal. Tuition was $750 per year for the "lower school" and $900 a year for the "upper school." Music was also part of the curriculum, including piano, guitar, mandolin, and cello, but below, these two youngsters appear to be holding ukuleles. Adelle Vollmers was the music teacher at the time of this photograph. (Both, courtesy of John Shroyer.)

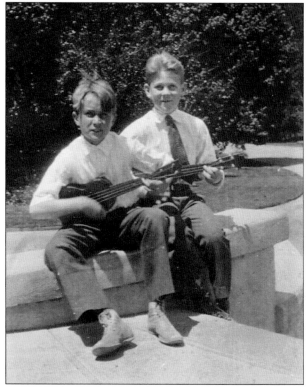

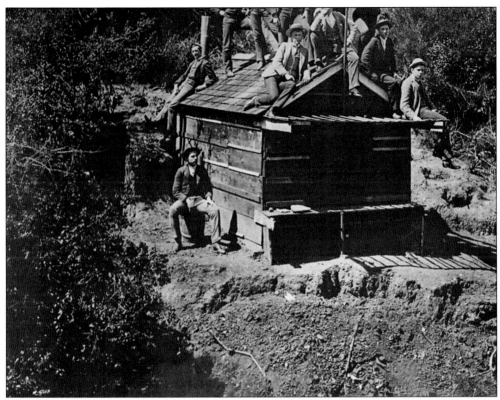

Students of the Belmont School were allowed to leave campus on weekends, and some built cabins in the hills near the school, as seen above. Below, these boys picnicked on "sodawater + crackers," Hutchinson Soda in particular, according to the notes on the back of this photograph. Picnickers are identified, in an unknown order, as follows: ? Ealand, Henry Herbert Yerrington (of Carson City, Nevada), Will Watt, Ralph Dodge Merrill (of San Francisco), Harry Gridley, and Ed Jack, all of which are names found in the 1896–1897 Belmont School catalog. The gymnasium is visible in the background. (Above, courtesy of Belmont Historical Society; below, courtesy of John Shroyer.)

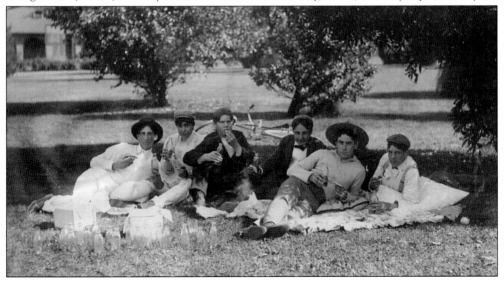

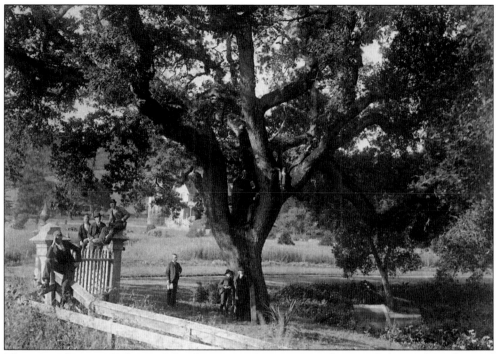

The original gate at Belmont School "was standing in 1891 when my father and mother and I went to live at the school—and stood for many years after—as did the beautiful white oak tree—maybe it was a live oak," wrote the sender of the above postcard. The photograph below, taken about 1892, shows the campus from the Reid home, at the intersection of Carlmont and Village Drives. The football field is now Carlmont Shopping Center. The flagpole was located on the site of the present Carlmont Gardens Nursing Home on Carlmont Drive. (Above, courtesy of John Shroyer; below, courtesy of Denny Lawhern.)

Catalogs for the Belmont School for Boys touted the rustic atmosphere of the peninsula location, describing Belmont as "a village on the Southern Pacific Railroad, twenty-five miles south of San Francisco. . . . The climate, the location, the surroundings, and the equipment of the school are probably unsurpassed." An 1899 school booklet described marches to "two miles east of the school" that attracted "many boys during the duck season." (Courtesy of John Shroyer.)

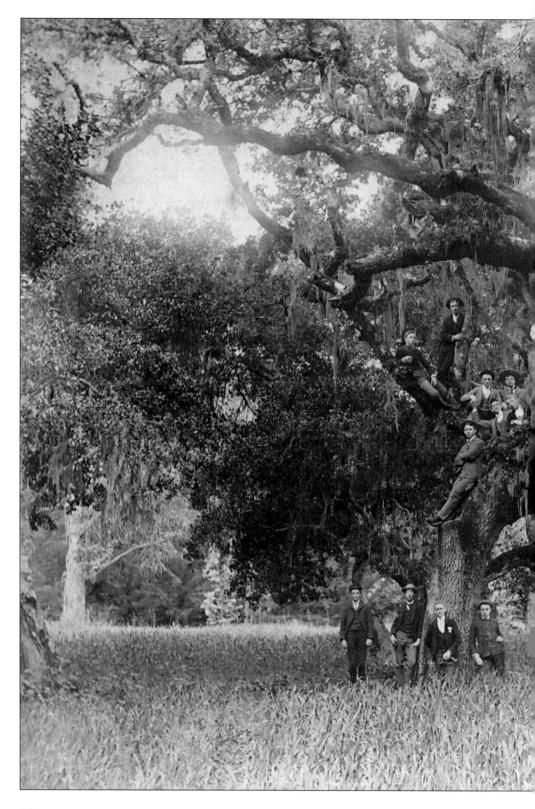

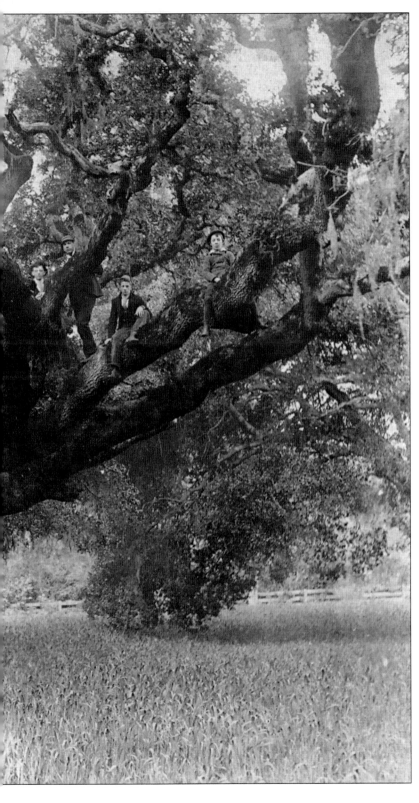

Belmont School for Boys students, and possibly a few teachers, pose for a photograph among the branches of an enormous oak on school grounds as if to prove the claims in their school's catalogs of a bucolic setting. On weekends, students were allowed to leave the campus, and many made trips to the beach at Half Moon Bay or to the Belmont Slough for oyster fishing and swimming. "A walk or ride of some twelve miles brings one to the shore of the Pacific, whose roar is not infrequently heard at the school after a storm," the school's catalog stated. The school was situated on both sides of Alameda de las Pulgas south of Ralston Avenue. (Courtesy of John Shroyer.)

An August 1894 advertisement from the *San Francisco Call* newspaper boasted about the school's facilities: "Buildings heated from a central steam plant, and buildings and grounds lighted by electricity." The young women and girl below are not identified, but Reid's family lived in Little Belmont, and music teacher Adella Vollmers, who lived in Senior House, took many photographs of the campus. Mrs. W.T. Reid (Julia) was an exhibitor at the San Mateo County flower show in Redwood City in 1895, according to another *San Francisco Call* article. (Both, courtesy of John Shroyer.)

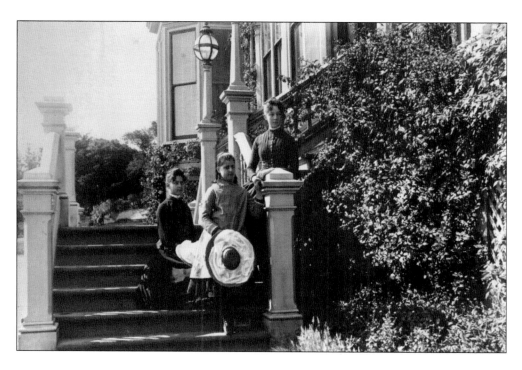

Sr. Monica Budde, shown in the undated photograph at right, taught chemistry at the College of Notre Dame from 1936 to 1970. In the photograph below, Sister Monica was joined by a teacher from the neighboring Notre Dame Belmont High School, Sr. V.J. LeMeaux, at a shallow part of Water Dog Lake. The College of Notre Dame purchased the Ralston estate for its schools, including the reservoir William Ralston built to serve Ralston Hall. The college is now known as Notre Dame de Namur University and the reservoir as Water Dog Lake. (Both, courtesy of Province Archives, Sisters of Notre Dame de Namur, California Province.)

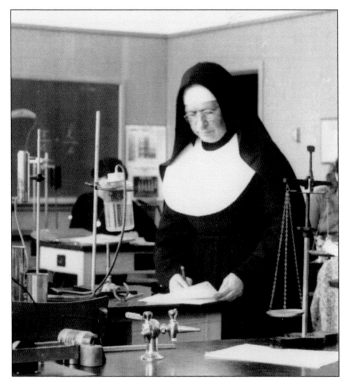

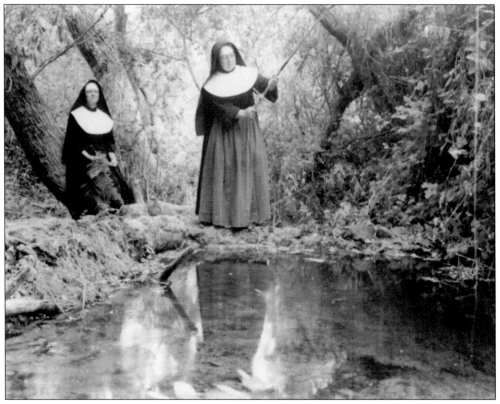

The Sisters of Notre Dame de Namur established the College of Notre Dame, California's first institution of higher education offering baccalaureate degrees to women, in San José in 1851. After the Sisters of Notre Dame de Namur moved their women's college from San José to Belmont in 1923, students lived, studied, and ate in Ralston Hall in the earliest years of the school. (Both, courtesy of Province Archives, Sisters of Notre Dame de Namur, California Province.)

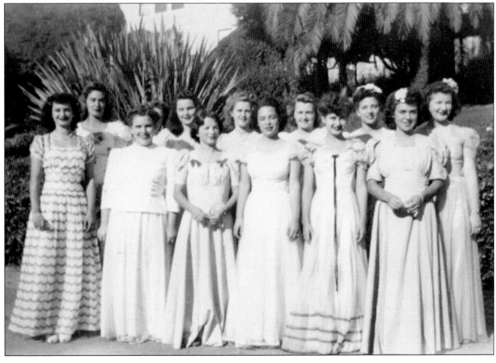

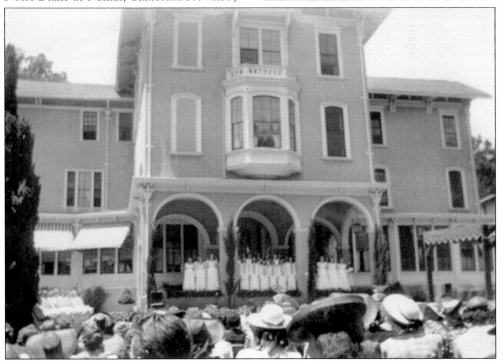

Where Bonanza king William Ralston once held lavish weekend parties for over a hundred guests in the late 1860s and early 1870s, College of Notre Dame student Mary Mapes found a quiet place to study in the library in the early 1940s. Ralston Hall's entrance, with Steamboat Gothic touches, also saw the likes of Leland Stanford and Ulysses S. Grant. The photograph below shows the College of Notre Dame's graduation exercises in 1941. (Both, courtesy of Province Archives, Sisters of Notre Dame de Namur, California Province.)

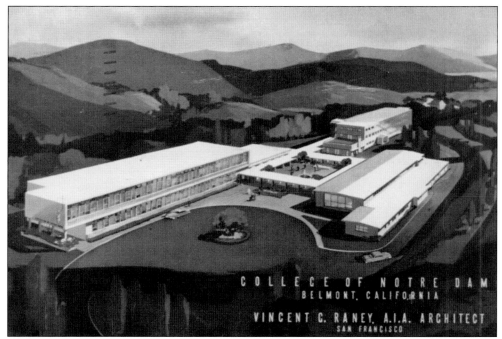

Postmarked on November 19, 1951, this postcard related the following message from Sr. Rose Marie: "This our new college at Belmont. How do you like it?" The sisters expanded the College of Notre Dame to include a residence hall, library, and classroom building. "We had a big week. School opened to public," Sr. Rose Marie's message continues. "Supervisors, Prin [short for principal] and teachers flocked in." Growth on the campus mirrored that in the town in the 1950s. The College of Notre Dame became coeducational in 1969 and changed its name to Notre Dame de Namur University in 2001. (Both, courtesy of Denny Lawhern.)

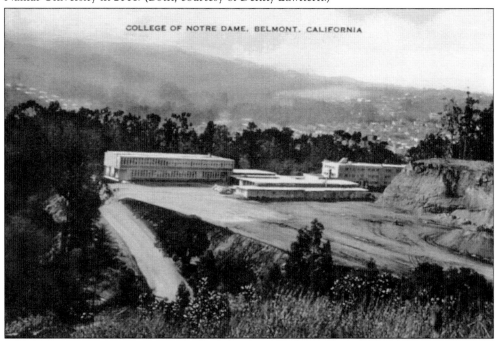

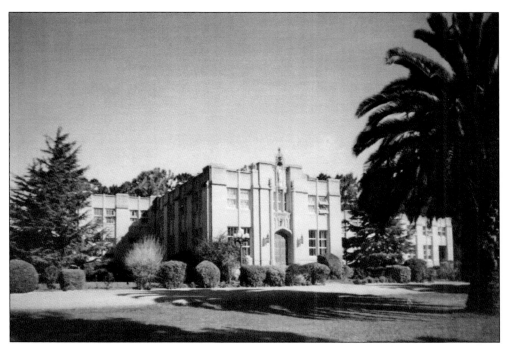

The Sisters of Notre Dame sponsor education from preschool through graduate school, all in Belmont, at Notre Dame de Namur University, Notre Dame Belmont High School, and Notre Dame Elementary School and Early Learning Center. The doors opened on neighboring Notre Dame Belmont High School, shown in the postcard above, in 1928. Vivian La Cava is identified as the diver in the undated postcard below. The pool is on the high school campus. (Both, courtesy of Denny Lawhern.)

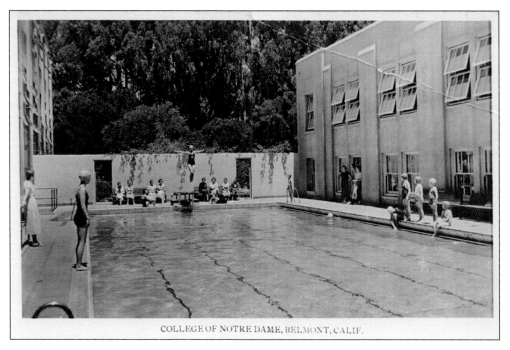

COLLEGE OF NOTRE DAME, BELMONT, CALIF.

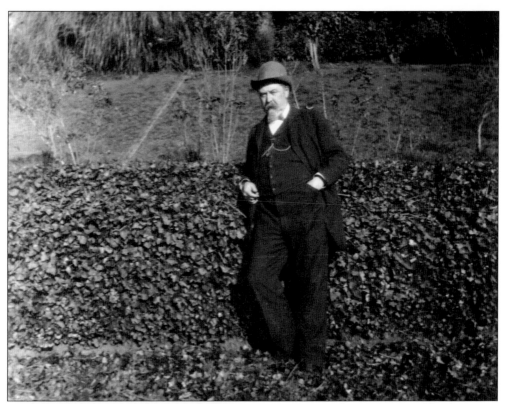

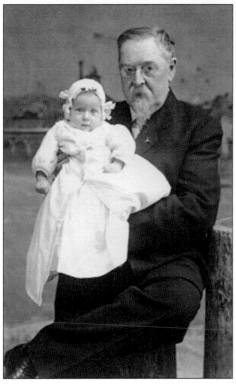

Born in New York in 1849, Dr. Alden Monroe Gardner (above) moved to California in 1877. A former superintendent of the Napa State Hospital, Dr. Gardner chose Belmont's Ralston Hall as the site for the Gardner Sanitarium for Nervous Disorders in 1901. Dr. Gardner is shown at left holding his granddaughter Lorna Ruth Fosberg, whose autobiography includes stories about her grandfather and her early childhood in Belmont. Dr. Gardner died in 1913. (Both, courtesy of Belmont Historical Society.)

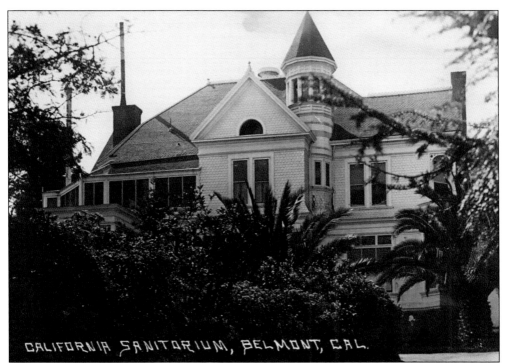

CALIFORNIA SANITARIUM, BELMONT, CAL.

The California Sanitarium's main building (above) was the former grand residence, dubbed Miramonte, of San Francisco's "macaroni king" Caesar Splivalo. In 1910, two doctors bought the house and land, which was located above the Belmont School for Boys, near Alameda de las Pulgas and Ralston Avenue. The handwritten message on the back of this 1915 postcard describes the house and site as "certainly a beautiful place." Caesar Splivalo occasionally made society news and was described in the *San Francisco Call* articles as being "prominent in society" and owning "a handsome estate in Belmont." (Both, courtesy of Denny Lawhern.)

Cottages 4 and 5 California Sanitarium, Belmont, California.

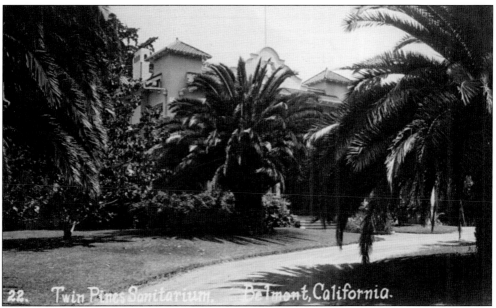

22. Twin Pines Sanitarium. Belmont, California.

Spooked by the 1906 San Francisco earthquake, banker George Center finished his solidly constructed country residence two years later. In 1925, the manor house became the Twin Pines Sanitarium, where doctors treated nervous disorders. Dr. William Rebec took the sanitarium from Dr. Norbert Gottbrath in 1930 and left Twin Pines to his staff when he died in 1941. Twin Pines closed in 1972. Later that year, Belmont residents passed a bond measure to purchase the property and create Twin Pines Park. (Courtesy of Denny Lawhern.)

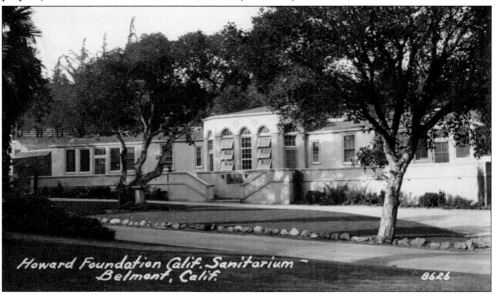

Howard Foundation Calif. Sanitarium - Belmont, Calif. 8626

Belmont residents today might recognize Merry Moppet Preschool and Belmont Oaks Academy on Carlmont Drive in this building, formerly the Howard Sanitarium for poor, urban children suffering from tubercular tendencies. The sanitarium opened in 1924 and operated well into the 1940s. The preschool moved into the building in 1957. The Alexander Sanitarium, which treated mental disorders, opened in 1924 across Ralston Avenue from the Gardner Sanitarium in Ralston Hall. (Courtesy of Belmont Historical Society.)

Five

EL CAMINO REAL
1899–1926

At the turn of the 19th century, automobiles were slowly gaining ground over trains. San Francisco newspapers began running advertisements for automobiles in the late 1890s. The "good roads movement" of the 1910s focused on paving roads built for horse riders, wagons, and stagecoaches. The *San Francisco Call* opened the year 1912 with an editorial headlined "Peninsula's Growth of Vital Importance to San Francisco," which stated that paving roads in San Mateo County would expand growth and help propel San Francisco to its "destiny" of becoming a great city. In February 1912, the *Call* sent a team of 20 motorists to San Mateo County to scout out the roads. "Roads in San Mateo Range Show No Ravages of Winter," the resulting report declared.

An accompanying map, under the headline "San Mateo Hills Fine for Touring: The *Call's* Studebaker-Flanders Pathfinder Explores Routes to Crystal Valley Lakes" showed a curving Ralston Avenue–Belmont Canyon Road connecting El Camino Real to the "lake road." Out of seven roads in San Mateo County connecting "the mission road" to "the lake road," Belmont's was described as the worst, as "quite rough in places" and with "bad chuck holes." Before Thanksgiving of that year, the *Call* asserted, "San Mateo County needs the road builder to make her presentable," prophesying that if San Mateo County voters approved a $1,204,000 bond to pave 104 miles of road as well as eliminate dangerous curves and reduce steep grades, they would be voting for their future. The *Call* urged San Mateo County to fix their roads to pave the way for visitors to the 1915 Panama Pacific Exposition in San Francisco. By 1918, El Camino Real in Belmont was moved from Old County Road east of the railroad tracks to Johnson Street on the west side of the tracks, slowly shifting the center of town in that direction.

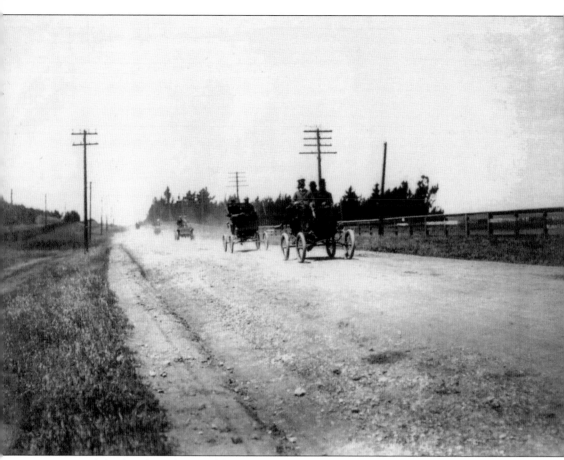

Automobiles head south on Old County Road, which was El Camino Real at the time, in this early 1900s photograph. Here, they are shown approaching the intersection with Ralston Avenue. Auto enthusiasts and clubs lobbied government to create highway commissions and to pave roads. The old "mission road" that connected missions from Baja California to north of San Francisco was a natural first choice. Paving El Camino Real, the main north-south artery connecting San Francisco to San José, began in 1912 but took a few years to reach Belmont. Belmont's Johnson Street was incorporated into the El Camino Real and renamed. (Courtesy of Belmont Historical Society.)

The Belmont Public School, shown in these photographs, opened in 1890. A year earlier, Belmont residents voted for a $5,000 bond to pay for the lot and construction of a school on the site of the old one, at the intersection of Old County Road and O'Neill Avenue. The previous school building had been constructed on Old County Road before the railroad tracks were laid. Eugene O'Neill bought the much smaller old school for $62.50 and moved the structure down the street. The new school had two classrooms on each floor and two teachers' rooms on the second floor. (Both, courtesy of Belmont Historical Society.)

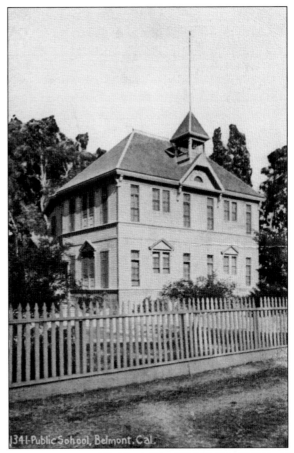

1341-Public School, Belmont, Cal.

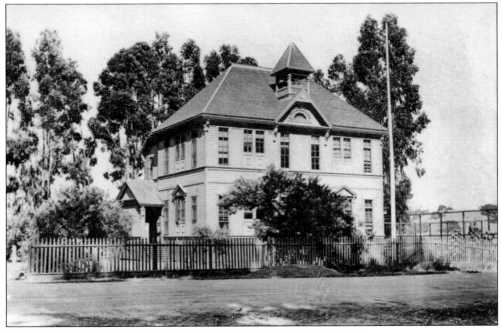

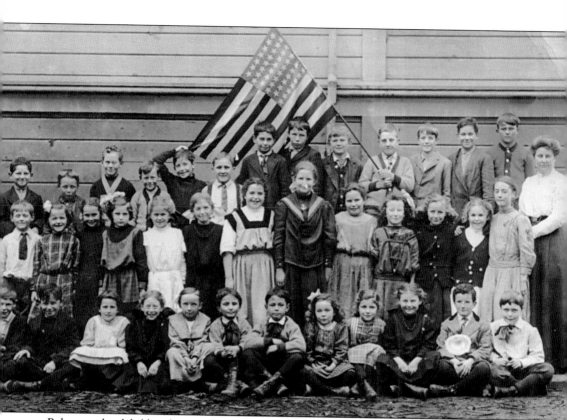

Belmont schoolchildren line up alongside the wall with their teacher Alice Thomas in the undated photograph above. This photograph was probably taken in the early 1900s or 1910s. The school was built in 1899 on what is now Old County Road. (Courtesy of John Shroyer.)

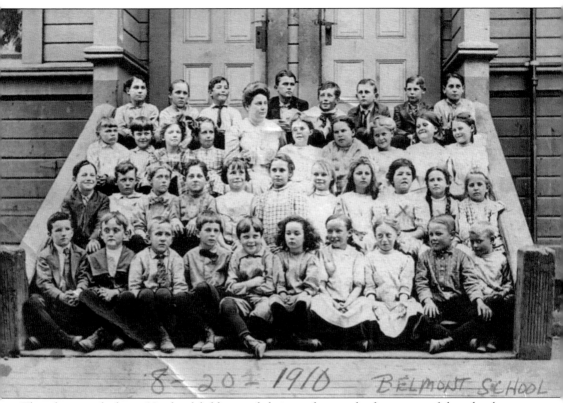

This photograph shows 38 schoolchildren and their teacher on the front steps of the school on August 20, 1910. The message on the back of this postcard notes, "Doris' face is swelled from a fall the day before," with Doris possibly being the girl with an X on her chest. (Courtesy of Denny Lawhern.)

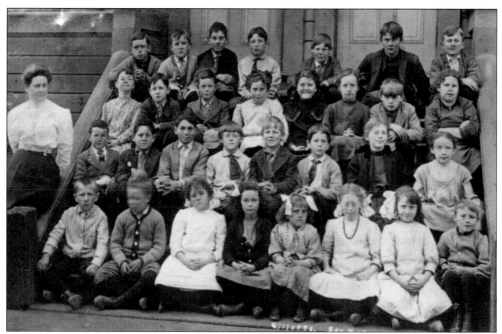

Alice Thomas stands next to her students sitting on the steps of the Belmont Grammar School in this 1912 photograph. The bell in the belfry was inscribed with school board members' names. Upper-floor classrooms were divided by folding doors that could be opened to create a hall for graduations. The class of 1917 was the last to graduate in this school. A few years later, a new school building would be constructed when El Camino Real was moved from Old County Road to across the railroad tracks as the town's center shifted west. (Both, courtesy of Belmont Historical Society.)

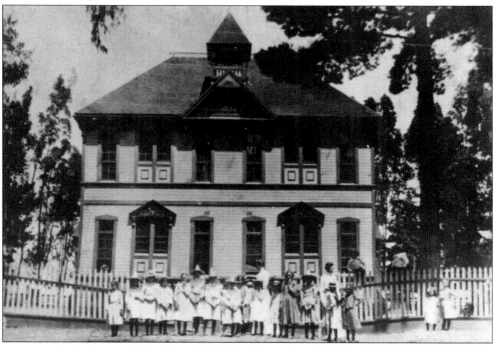

This undated photograph shows the Bourdette ranch and orchard, looking north. Unhappy about Belmont's incorporation in 1926, attorney John W. Bourdette filed a lawsuit the following year, claiming that the city had no right to incorporate agricultural land, which included his 30-acre ranch. A Superior Court judge ruled in Bourdette's favor, but the State District Court of Appeals reversed this decision in 1929. The Bourdette family home was located where Carlmont High School now stands. (Courtesy of Belmont Historical Society.)

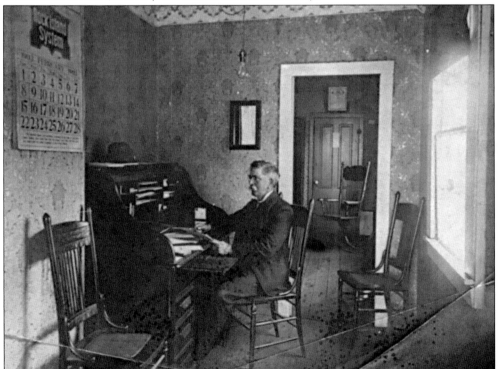

Amasa P. Johnson, shown here in his real estate office on Ralston Avenue in February 1903, found himself in court in December 1901 with a lawsuit against the Southern Pacific Railroad Company over land condemned along the railroad tracks. Johnson wanted $2,000 for the land and $5,000 in damages to land he owned nearby. The court allowed him $1,000 for the land and $600 for damages. (Courtesy of Belmont Historical Society.)

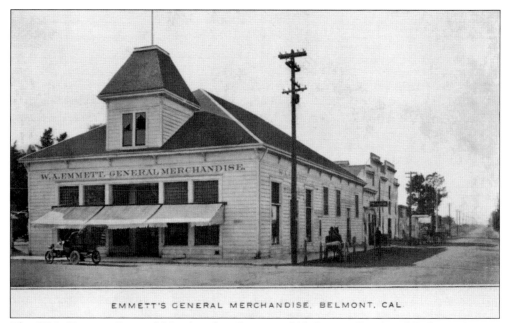

EMMETT'S GENERAL MERCHANDISE, BELMONT, CAL.

The W.A. Emmett General Merchandise Store on Old County Road and Ralston Avenue was located around the corner from the Belmont train station. Postmarked in Santa Clara on August 4, 1908, this postcard was mailed to Sonoma to let the recipient know that the traveler had made it "all right" to San José. Halfway between San Francisco and San José, Belmont was a natural place for a brief stop. (Courtesy of Denny Lawhern.)

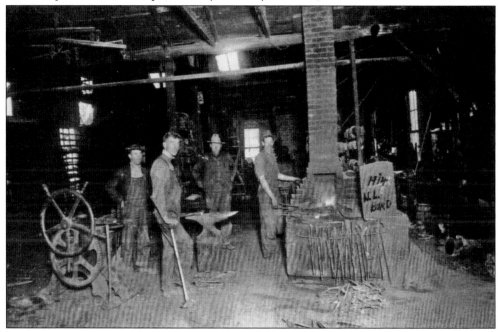

Hammerson's Blacksmith Shop, shown in this 1914 photograph, was located near the southeast corner of Old County Road and Ralston Avenue. Previous smiths on this site were Adam Castor and J.N. Oliver. Hammerson took over in 1880 and leased the shop in 1912 to William L. Burd, the blacksmith at the forge in this photograph. (Courtesy of Belmont Historical Society.)

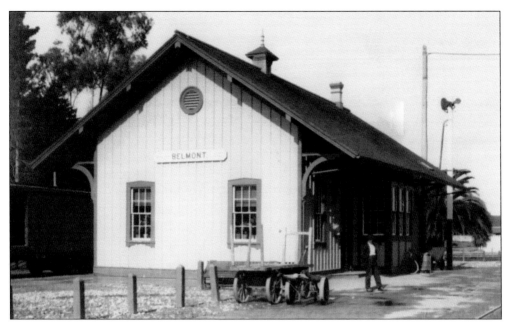

An unidentified man waits at the Belmont train station in 1915. The train station, on El Camino Real north of the intersection of Ralston Avenue, stood until 1952. Train information was a marketing tool for developers. One boasted in 1925 of the "25 fast commute trains a day" stopping in Belmont from San Francisco and San José. (Courtesy of Belmont Historical Society.)

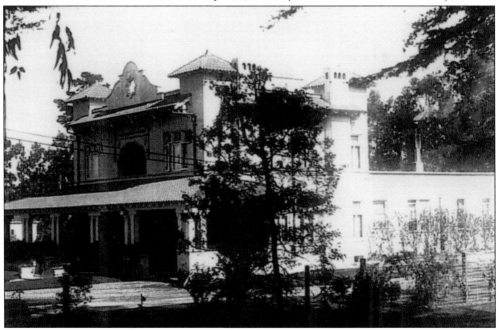

Shaken by San Francisco's devastating earthquake in 1906, Ralston associate and former San Francisco city supervisor George Center built his country home, pictured here in 1915, a few years later in Belmont. The solidly built manor house later became Twin Pines Sanitarium after Center's death in 1923. Now the grand house is the centerpiece of Twin Pines Park. (Courtesy of Belmont Historical Society.)

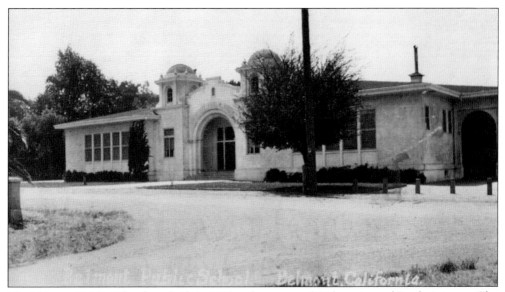

The Belmont Public School was built in 1918 at the corner of Waltermire and Sixth Avenues. The Mission Revival–style building was razed in January 1967 and the lot sold to save the expense of bringing the building up to state earthquake safety standards. A Safeway supermarket now stands on this site. (Courtesy of Belmont Historical Society.)

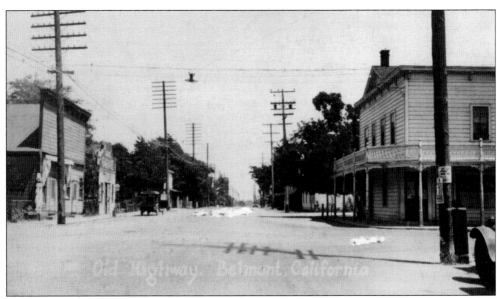

Early commercial buildings at the old crossroads of Old County Road and Ralston Avenue looked quaint on the eve of Belmont's incorporation in 1926. The "Old Highway" labeled on this undated photograph is Old County Road, replaced by this time by El Camino Real, the "Grand Boulevard" that connects San Francisco to San José. (Courtesy of Belmont Historical Society.)

Six

A Town Forms and Grows
1926–1945

When Belmont incorporated in 1926, Prohibition was six years old—not that the Volstead Act shut down the bars on El Camino Real and Old County Road. No sooner had Belmont residents voted to incorporate than attorney John Bourdette filed a lawsuit stating that the city had no right to incorporate agricultural land, including his 30-acre ranch. A Superior Court judge ruled in Bourdette's favor, but the State District Court of Appeals reversed this decision in 1929.

Developers in the 1920s looked to create another Hillsborough-like enclave. The Belle Monti Country Club was built in 1926 on a rise on Alameda de las Pulgas with a view of the valley and Ralston Hall. The clubhouse, with golf course, swimming pool, and tennis courts, cost $65,000 to build. Memberships sold for $100, but the stock market crash of 1929 lead to bankruptcy for the corporation.

The 1912 phone book had 16 listings for Belmont, including the Belmont Hotel, the Belmont School for Boys, the sanitariums, and a few successful businessmen like George Center. By 1929, the San Mateo County telephone directory listings for Belmont showed the outlines of a modern town. Although no attorneys, bakers, banks, druggists, jewelers, laundries, insurance companies, or pharmacists were listed in Belmont as they were for neighboring towns, two physicians, P.J. Perkins and Homer Van Horn, set up practice. Ralston Avenue sported the Paul Miller Barbershop, Belmont Cleaners, and Belmont Market. Belmont Feed & Fuel Co. on Fifth Avenue provided coal. A florist was also located on Fifth Avenue. On Old County Road near Ralston Avenue were the following establishments: Belmont Garage, Fred Johnson's Garage, Peninsula Hardware, Belmont Meat Market, and the Belmont Hotel, run by H.C. Caldwell. C.J. Messner's store on Emmett Avenue at Old County Road was the news dealer. *Belmont Courier* publisher E.J. Halcrow was located on Old County Road as well.

Daley Bros. Builders, developers of the Belburn Village Tudor-themed subdivision near Notre Dame Belmont High School, had their office on Bellview Drive. Contractors C.B. Ray and Charles F. Magne were at 412 Sunny Slope Avenue. In 1929, two nursery owners, F. Karija and M. Uchida, were listed on Old County Road. The chrysanthemum fields off Old County Road in today's Homeview neighborhood were famous, but World War II brought the order to remove Japanese Americans from their land and place them in internment camps. In 1940, Belmont's population rose to 1,229 from 984 a decade earlier. The war would bring great change to the "town of the sixth class," the designation for the smallest towns.

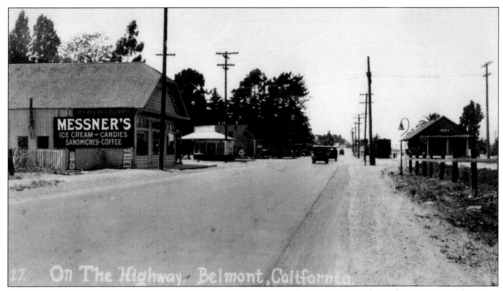

Automobiles travel past the Belmont train station on El Camino Real in the 1930s. Belmont's location halfway between San Francisco and San José made it an ideal site for the gas station and store shown in this view looking north on El Camino Real from Ralston Avenue. The store's owner, Columbus Messner, was elected to Belmont's first board of trustees when the town incorporated in 1926. (Courtesy of Belmont Historical Society.)

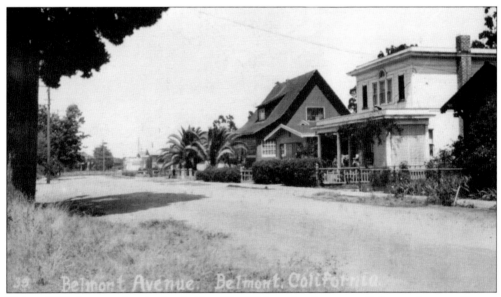

This c. 1930 photograph mistakenly identified Waltermire Avenue as Belmont Avenue. Grocer Columbus Messner built the first house on the right about 1920. Bertrand Johnson, an engineer with the Pacific Telephone Co., built the next one about 1924, and William Rousel built the third house about 1905. These houses, at 935, 925, and 901 Waltermire Avenue, are now part of the Downtown Historic District. (Courtesy of Belmont Historical Society.)

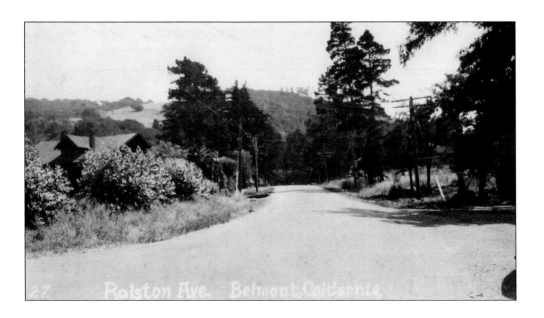

Both of these undated photographs come from a series thought to be part of either an effort to record the newly incorporated town around 1926 or a Works Progress Administration project in the mid-1930s to provide work. The photograph above (labeled "27. Ralston Ave. Belmont, California.") shows an unidentified portion of Ralston Avenue, and the one below (labeled "26. S.P.R.R. Depot. Belmont, California.") shows the Southern Pacific Railroad depot at El Camino Real and Ralston Avenue, where it is today. (Both, courtesy of Belmont Historical Society.)

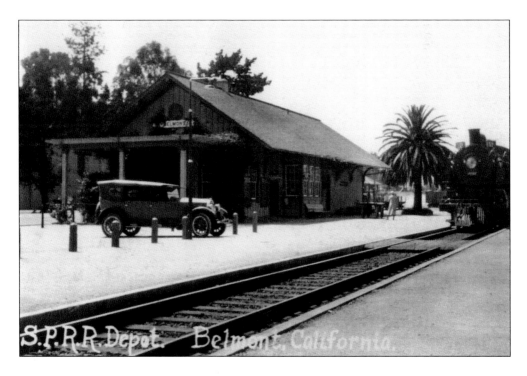

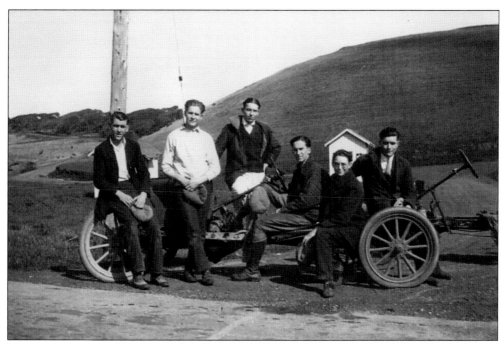

These young men—identified on the photograph above (their order unknown) as Stanley Botto, Harry Eichenberger, John Staugus, Fred Eichenberger, Earl Miller, and Sidney Johnson—took a stretch of road identified as "Ralston Grade" by storm in 1925. Meanwhile, across town in the same era, three unidentified men appear to mimic a shoot-out in the intersection of Old County Road and Ralston Avenue in the photograph below. West of Alameda de las Pulgas, Ralston Avenue became Belmont Canyon Road. Old County Road was the main north-south road. The American House is on the left. (Both, courtesy of Belmont Historical Society.)

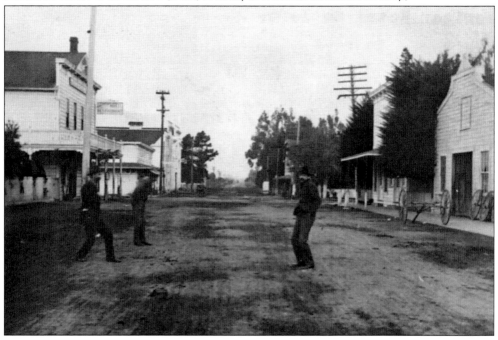

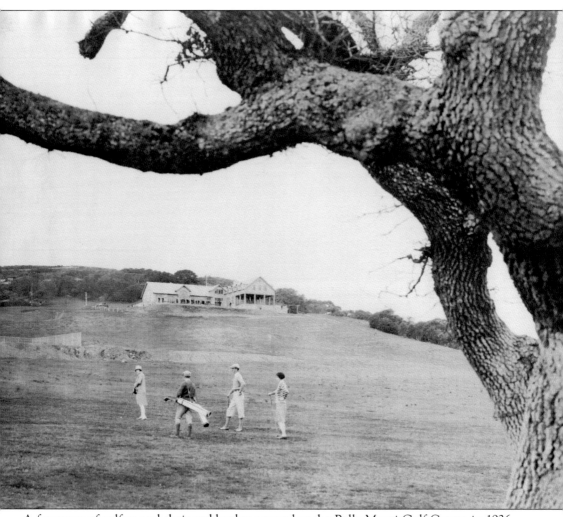

A foursome of golfers and their caddy play a round at the Belle Monti Golf Course in 1926. The building on the hill is the clubhouse of the Belle Monti County Club. The military used the clubhouse during World War II. Today, it is the Congregational Church of Belmont at 751 Alameda de las Pulgas. The golf course is now the neighborhood west of Notre Dame Belmont High School. Street names commemorate developers Lee Monroe, Arthur Lyon, Lawrence Miller, and Simon Monserrat Mezes, who first subdivided this area. (Courtesy of California Historical Society, San Francisco Chamber of Commerce Collection, CHS2013.1236.)

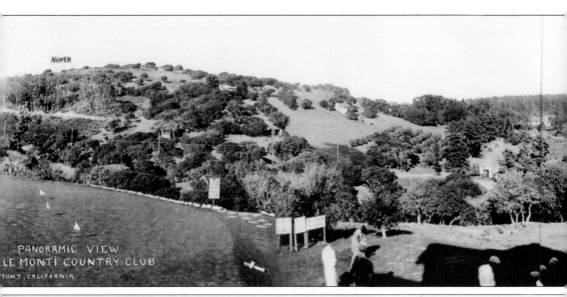

North

PANORAMIC VIEW
LE MONTI COUNTRY CLUB
ONT, CALIFORNIA

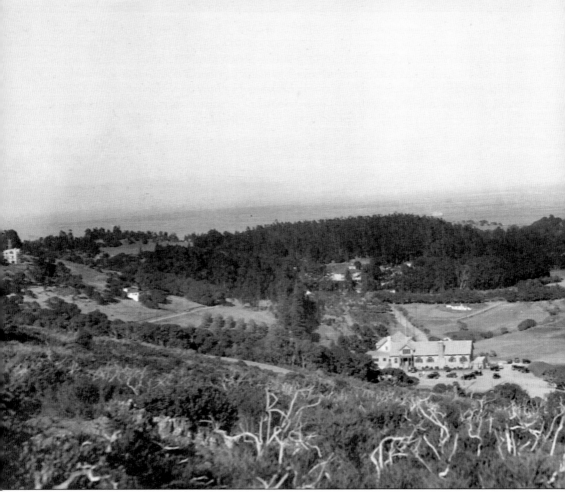

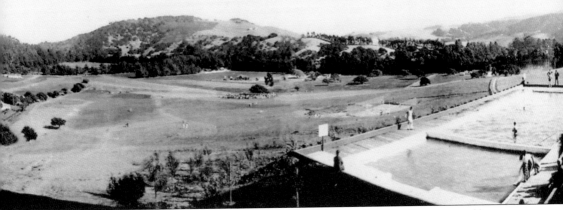

The view above shows the valley that became a golf course. The Belle Monti clubhouse swimming pool is visible in the foreground. The 1,000-lot subdivision was bordered by Alameda de las Pulgas to the west, Fairway Drive and Arbor Avenue on the east, Notre Dame Avenue on the south, and Bay View Drive and Forest Avenue to the north. The Burlingame-based Daley brothers developed Belburn Village with a Tudor theme described as follows: "A cozy little community of colorful, English-type cottages . . . a sunny, happy little settlement, where kiddies can romp outdoors the livelong day." The photograph at left shows the view from above the clubhouse in June 1926. (Both, courtesy of Belmont Historical Society.)

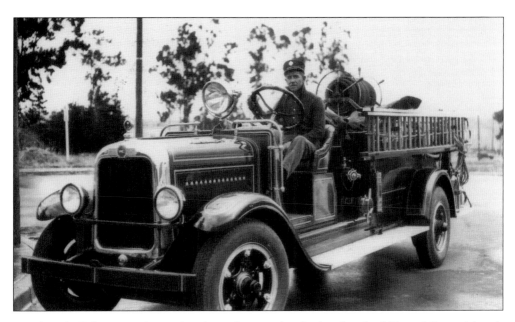

Two firsts for Belmont are featured in these photographs: the first fire chief, Elwood Curtis (above), shown in 1929, and the first chief of police, Irwin "Slim" Hansen (below), shown standing in front of the Southern Pacific Railroad station in Belmont in 1930. The fire department held several fundraisers at Belle Monti Country Club in order to buy firefighting equipment. The fire station at 875 O'Neill Avenue was a Works Progress Administration project built in 1935. Irwin Hansen was sworn in four years after Belmont incorporated and was the lone law enforcement officer for a short while. (Both, courtesy of Belmont Historical Society.)

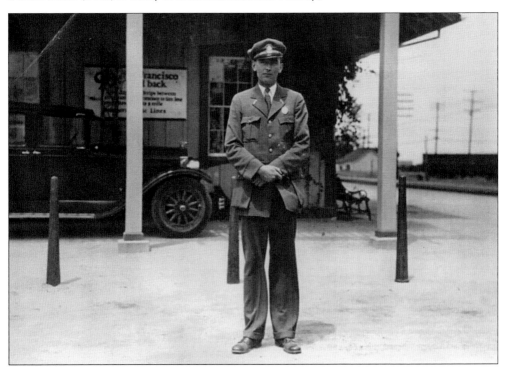

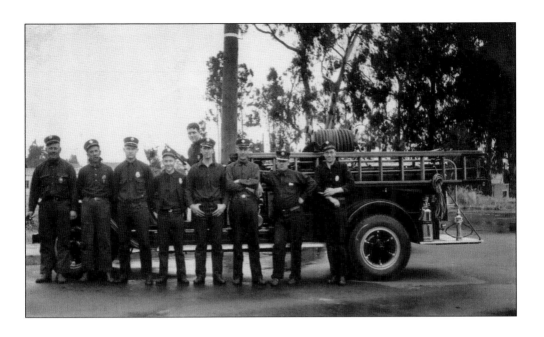

Belmont's firefighters happily line up in front of their American LaFrance truck in 1934 (above). Belmont proudly sported two fire trucks (below) that year, three years after the town had incorporated. In 1926, the fire board contracted to purchase a used fire engine from Seagrave Corporation for $250 down and $250 a year. American LaFrance engines in 1929 commonly cost about $2,200. The twin garages shown below were located on O'Neill Avenue, one block over from the Belmont Grammar School on Waltermire Avenue, where the Belmont Volunteer Fire Department held its first meeting on June 21, 1926. (Both, courtesy of Belmont Historical Society.)

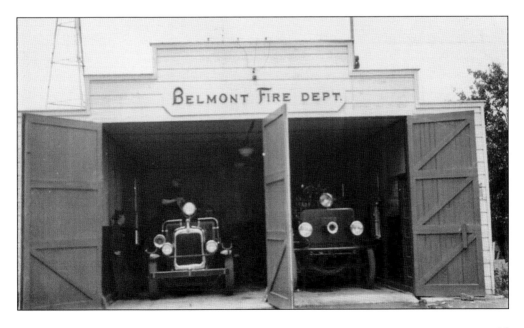

Firemen and police officers join city officials (above) in front of Belmont's fire department, housed in the Mediterranean Revival stucco buildings at O'Neill and Fifth Avenues (below). Fire board meeting minutes from the 1930s record the occasional recess to listen to the popular radio show *Amos and Andy* as well as Belmont's notable "big winds" that often cut electrical power to the small town. Belmont grocery store owner and Waltermire Avenue resident C.J. Messner often provided "sugar, milk, etc.," for evening meetings at a cost of around $1.32. (Both, courtesy of Belmont Historical Society.)

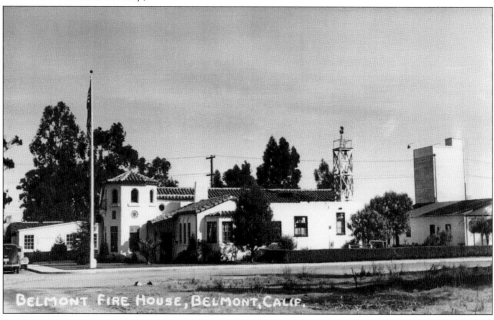

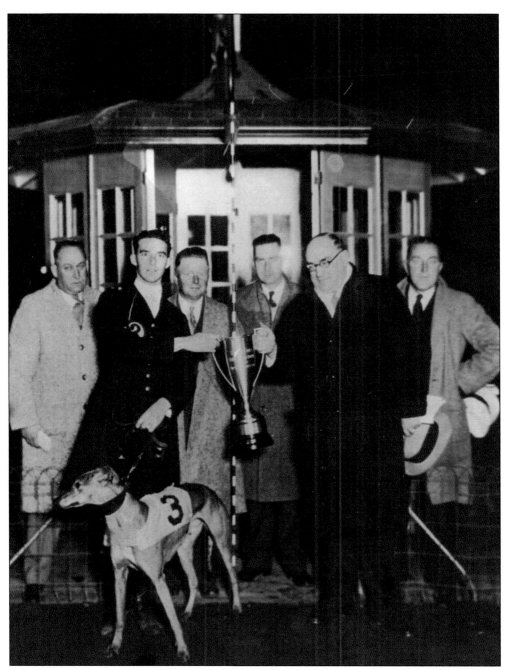

Belmont mayor and municipal judge C.L. Jordan joined local luminaries at the October 31, 1931, opening of the Bayshore Kennel Club, which was located in today's Sterling Downs neighborhood. From left to right are Jack Fisher, head judge; the unidentified owner of the winning dog; Jordan; M. Johnson, a track employee; Horace Amphlett, publisher of the *San Mateo Times*; and Jack Hoey, a race judge. (Courtesy of Belmont Historical Society.)

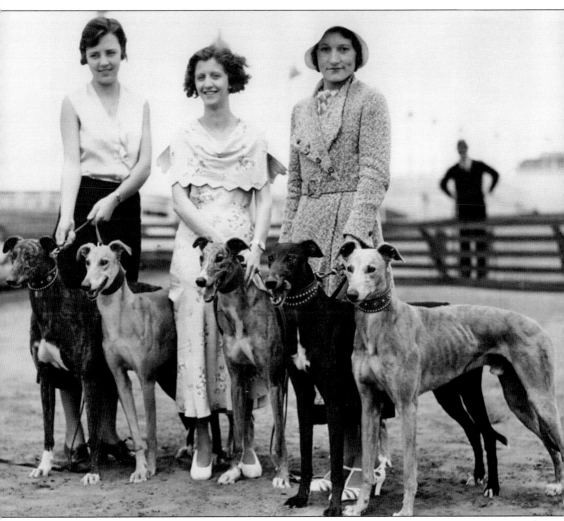

Miss Belmont, a Miss Miller (far right), and two other unidentified young women pose with greyhounds, probably as part of the opening ceremonies in 1931. The program announced, "Ritzy greyhound racing plant opens tonight with a card of evenly matched races. . . . Jolly Good Luck to You All!" (Courtesy of Belmont Historical Society.)

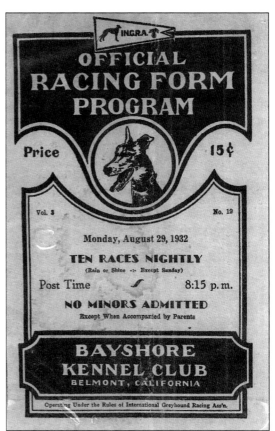

This program for greyhound races at the Bayshore Kennel Club promised, "Ten races nightly, rain or shine," with a post time of 8:15 p.m. The San Mateo Times Company printed kennel club programs and forms. Minors were not admitted unless accompanied by an adult. "The International [Greyhound Racing Association] is synonymous with all that is clean, wholesome and legitimate in greyhound racing," the program stated. The track closed in the late 1930s when greyhound racing, shown below, was made illegal in California. (Both, courtesy of Belmont Historical Society.)

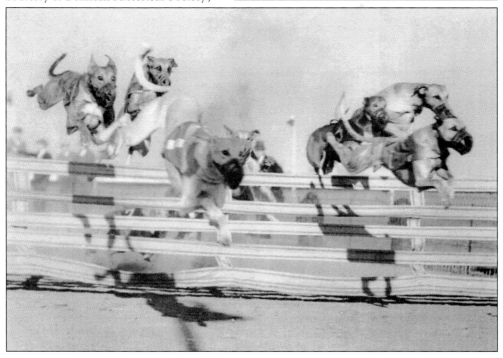

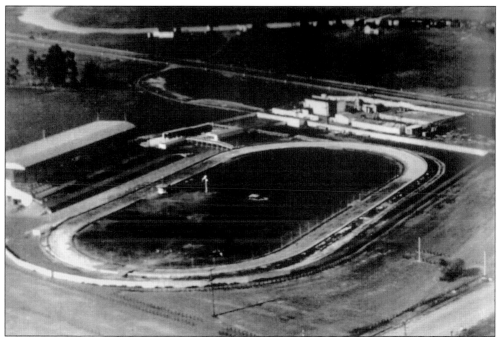

This aerial view of east Belmont shows the greyhound racetrack's oval in the foreground, a slaughterhouse just beyond the track, and a settlement known as Shantytown, comprised of 20 or so small wooden structures along a boardwalk in the O'Neill Slough. Capt. Owen O'Neill built a dock for his schooner, which ferried passengers and freight to San Francisco before the railroad. His son built sheds for duck hunters, and later, some were used as bathing houses. The Belmont Fire Department burned Shantytown in 1953. The area is now part of the Belmont Sports Complex. (Both, courtesy of Belmont Historical Society.)

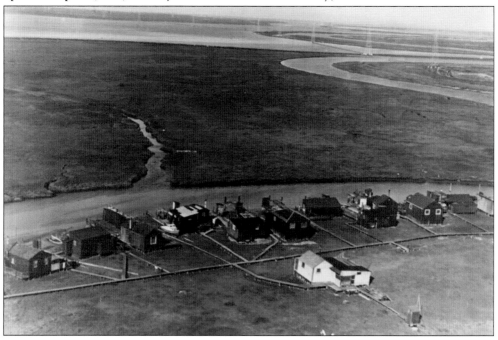

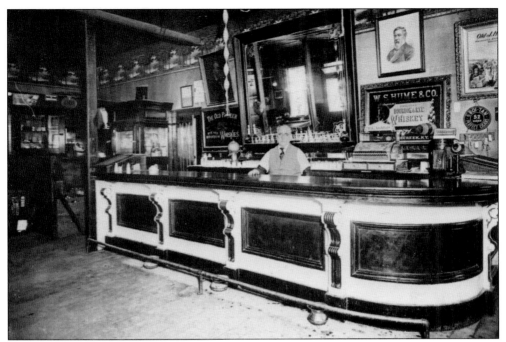

This unidentified bartender at the American House bar was not alone for long, as accounts hold that this photograph was taken when Prohibition was repealed in 1933. The American House was situated in Belmont's commercial center, along with the Emmett Store and other businesses at the intersection of Old County Road and Ralston Avenue. (Courtesy of Belmont Historical Society.)

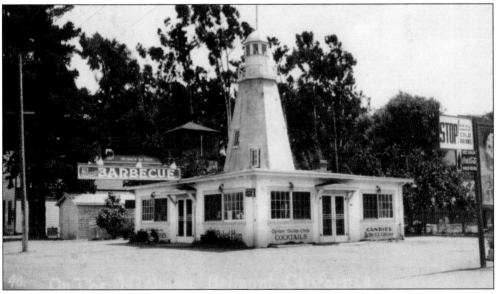

This photograph shows "Bob and Oscar's Lighthouse Restaurant" in 1936 or 1937, according to handwritten notes on the back. "It's fine in the Stein" declares the small sign above the barbecue sign for the unique eatery on El Camino Real and Waltermire Street. This site is now a parking lot for Safeway. (Courtesy of Belmont Historical Society.)

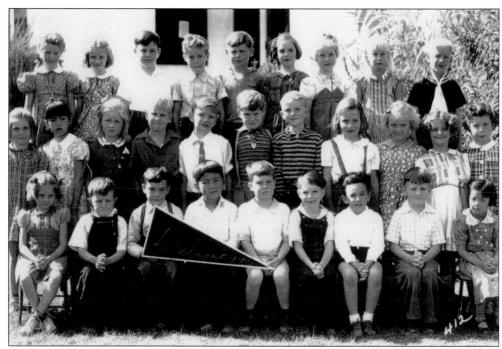

Third- and fourth-grade students of Belmont Central School pose for their annual portrait in 1939. Today, Belmont's Central School is on Middle Road. High school students from Belmont attended Sequoia High School in Redwood City. (Courtesy of Belmont Historical Society.)

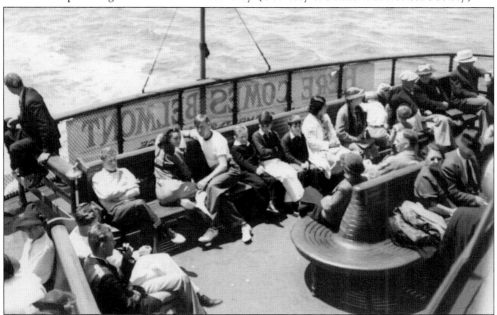

"Here Comes Belmont" proclaims the banner at the bow of a ferry carrying Belmont and San Carlos residents to the World's Fair on Treasure Island on June 9, 1939. The boat, sponsored by the Belmont Chamber of Commerce, embarked from Redwood City at 9:30 a.m. and left Treasure Island at 6:30 p.m. Round-trip tickets cost $1, which included dance music by Lamb's Orchestra. (Courtesy of Belmont Historical Society.)

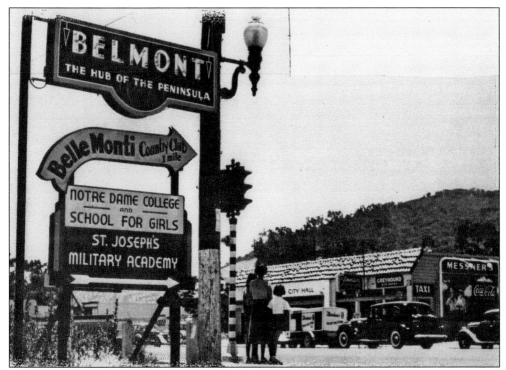

Per this sign on the southeast corner of El Camino Real and Ralston Avenue, Belmont was long known as "the Hub of the Peninsula," as this early 1930s photograph attested. The Belle Monti Country Club corporation had defaulted by the time this photograph was taken. St. Joseph's Military Academy remained open until 1952, when the site became Immaculate Heart of Mary School. Notre Dame College and School for Girls are still in operation as Notre Dame de Namur University and Notre Dame Belmont High School. (Courtesy of Belmont Historical Society.)

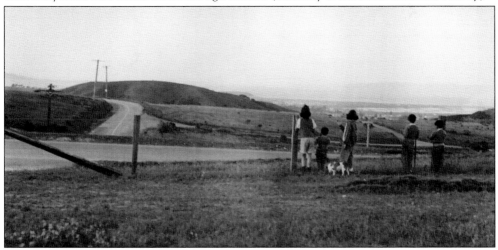

The youngsters in this c. 1940 photograph take in the view from atop the hill situated to the west of today's Ralston School. The new grading closest to the fence and the children is Ralston Avenue, a straight thoroughfare to replace Belmont Canyon Road's curves around the hills. Historically, Belmont Canyon Road appears on maps also as Cañada de Raimundo Road and Diablo Canyon Road. Sugarloaf Mountain is visible in the distance. (Courtesy of Belmont Historical Society.)

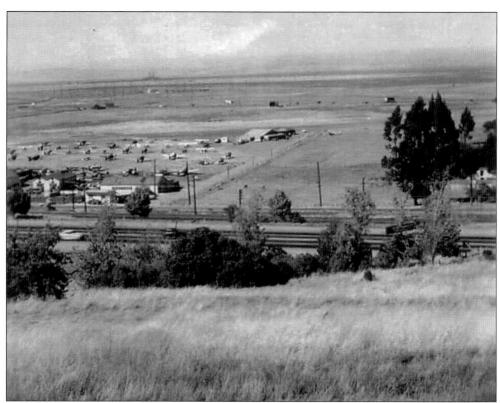

The Belmont Airport, shown in the c. 1941 photograph above, would have been reached from Old County Road and east on Marine View Street. The runway would have been located where Hiller Street and Chesterton Avenue are today. The 76th Field Artillery Battalion was transferred to temporary headquarters in Belmont in 1942, forming Camp Belmont (shown below), near the current location of Mae Nesbit School on Biddulph Way, east of Old County Road and north of Ralston Avenue. (Both, courtesy of Belmont Historical Society.)

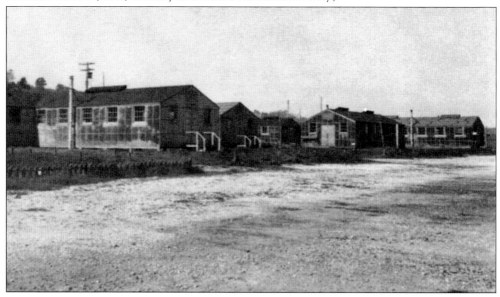

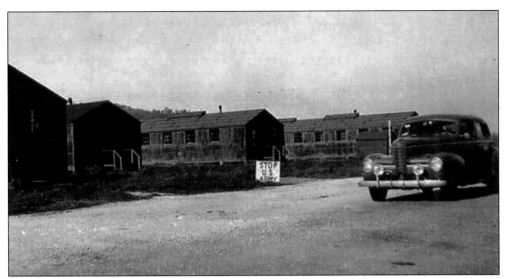

Camp Belmont (above) was one of dozens of Army installations along the Pacific Coast established during World War II to guard against attacks from Japan. Some of Belmont's Japanese American residents operated nurseries where the Sterling Downs and Homeview neighborhoods are today—in fact, Belmont was once known as the Chrysanthemum Capital of the World—before being removed from their homes and land per Executive Order 9066. In 1942, the aircraft observer post on Newlands Avenue (below) was staffed by Doris Vannier (left, outside) and Florence Underwood (right, inside), according to handwritten notes on the back of this photograph. (Both, courtesy of Belmont Historical Society.)

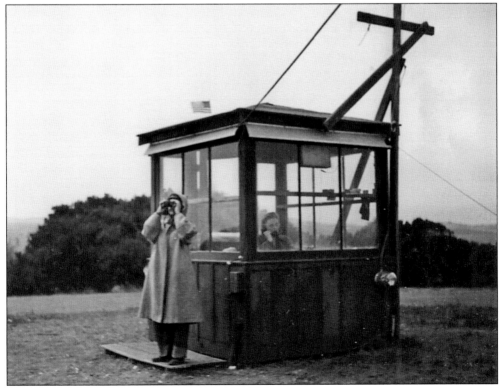

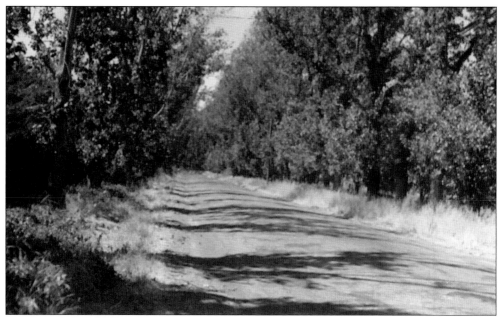

In 1945, Alameda de las Pulgas was a narrow dirt road lined with trees. The photograph above shows the section of the *alameda*, or "highway," in front of Carlmont High School. Now, Alameda de las Pulgas is a heavily traveled secondary artery connecting Hillsborough, Burlingame, San Mateo, Belmont, San Carlos, Redwood City, Menlo Park, and Palo Alto. Below, Walter Emmett's house originally stood at 843 Ralston Avenue (a block away from the Emmett Store) when it was built in 1885, but it has since been moved to Sixth and O'Neill Avenues and restored. (Both, courtesy of Belmont Historical Society.)

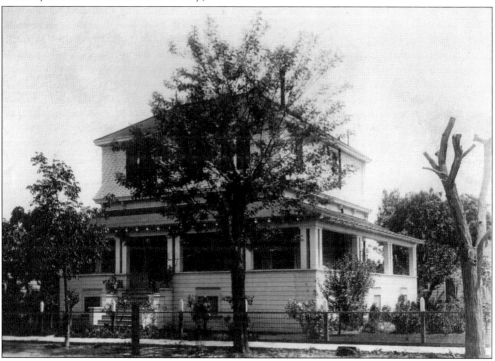

Seven

GREETINGS FROM BELMONT
1870s–1970s

Postcards tell of a town's attractions. In Belmont, those attractions range from opulent Ralston Hall, or "the White House of the West," to a casino near a racetrack. In the 1880s, postcards from Belmont featured a general store near the train station and an exclusive boys' preparatory school. In the 1950s, an era of expansion, a newly constructed public high school and motels along El Camino Real, the main San Francisco–San José connector at the time, made their way to the front of real-photo postcards from Belmont.

Ralston Hall, in its various incarnations, from Dr. Gardner's Sanitarium to the College of Notre Dame (now Notre Dame de Namur University), has graced many a postcard. The historic landmark's famous mirrored ballroom, reception room, vestibule, and gardens perhaps burnished the image of the small suburban town halfway between glittering San Francisco and the agricultural Santa Clara Valley. Neighboring Notre Dame Belmont High School, its stately 1928 terra-cotta-colored stucco buildings set back from Ralston Avenue across an expanse of lawn, has long caught the eye of motorists driving through Belmont, as well as photographers. A century ago, postcards featured almost every aspect of life at the exclusive Belmont Boys School.

Belmont's location halfway between San Francisco and San José made it a natural stopping place, and the W.A. Emmett General Merchandise Store around the corner from the Belmont train station would have been a likely place for a train passenger to purchase a postcard. A postcard postmarked in Santa Clara on August 4, 1908, includes a message to the traveler's daughter in Sonoma that she had made the trip to San José "all right." Patients at any one of the seven sanitariums that once operated in Belmont sent real-photo postcards showing the elegant exteriors of the Victorian California Sanitarium or the Twin Pines Sanitarium housed in the Mediterranean Revival home built by banker George Center.

From the palatial to the pedestrian, postcards boast about a small piece of a town. Greetings from Belmont!

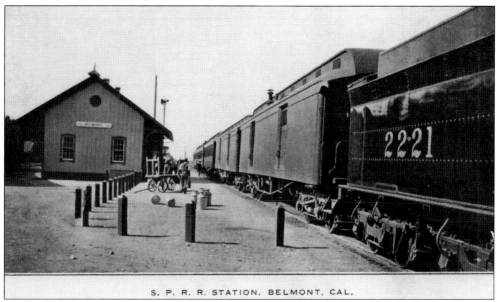

In September 1863, trains ran from San Francisco to just past Palo Alto, on the route of which Belmont was a stop. When the railroad connected to San José the next year, a trip from San Francisco to San José took three and a half hours, an improvement over the eight-hour stagecoach ride. In August 1867, Belmont inherited Menlo Park's old depot, which was placed west of the railroad tracks, north of Ralston Avenue. (Courtesy of Denny Lawhern.)

Cunningham Memorial Chapel on the Notre Dame de Namur University campus, shown on this postcard at night, is the modern contrast to Ralston Hall. With a marble altar, a pipe organ and a grand piano, and etched-glass windows by French artist Gabriel Loire, the chapel, which seats 500, is often used for musical performances and events. The chapel was built in the early 1960s, when the then College of Notre Dame expanded and built an upper campus. (Courtesy of Denny Lawhern.)

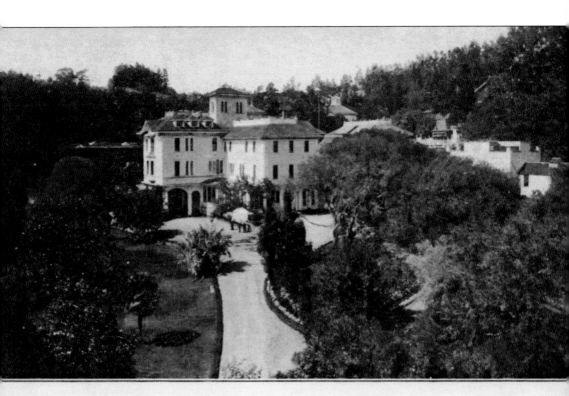

A bird's-eye view of Ralston Hall from the south advertised the "nerve rest" sanitarium operated by neurologist Dr. Alden Monroe Gardner from 1901 until his death in 1913, when his son Sherman Gardner took over. Dr. A.M. Gardner purchased the villa and grounds for $35,000 in 1900 and opened his sanitarium for nervous disorders the following year. (Courtesy of Denny Lawhern.)

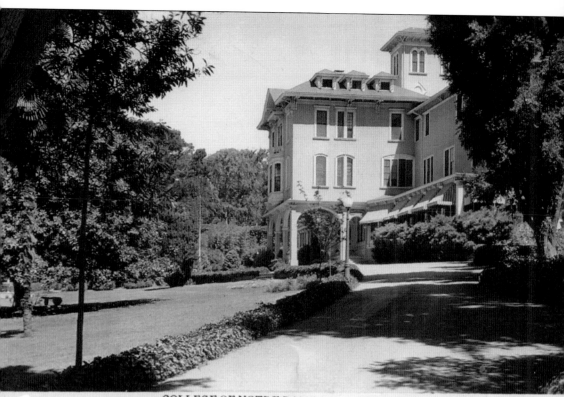

COLLEGE OF NOTRE DAME, BELMONT, CALIF.

Undeniably Belmont's most recognizable view and most photographed structure, Ralston Hall's entrance looks much the same today as it did in this undated postcard. Here, the Italianate villa is identified as the College of Notre Dame, but the elegant 55,000-square-foot mansion began as a banker's country estate and also served as a sanitarium. Financiers, statesmen, doctors, patients, nuns, students, brides, and wedding guests have entered through this entry. (Courtesy of Denny Lawhern.)

ENTRANCE DRIVE, SHOWING BAMBOO HEDGE TO THE RIGHT, COLLEGE OF NOTRE DAME, BELMONT, CALIF. 560

The decorative stone wall pictured in the postcard above is gone, but the bamboo hedge thrives today, providing a background to many a wedding photograph. The caption identifying the location as College of Notre Dame means this photograph was taken in or after 1923, when the Sisters of Notre Dame de Namur purchased Ralston Hall for their women's college. Known as Notre Dame de Namur University since 2001, the university rents grand Ralston Hall for weddings and other events. If one were to continue down the entrance drive, one would circle around to the northern side of Ralston Hall, shown in the postcard below. (Both, courtesy of Denny Lawhern.)

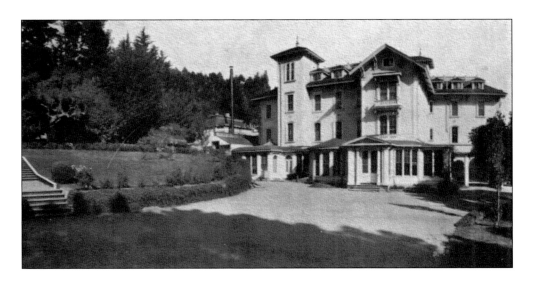

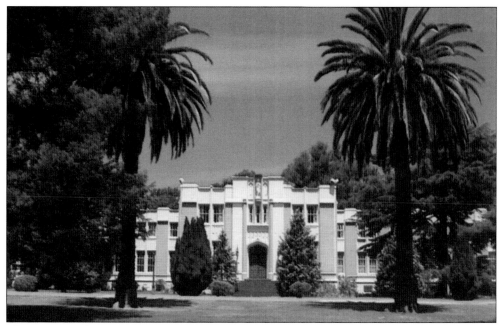

This c. 1980 color postcard shows off the 1928 facade of Notre Dame Belmont High School on Belmont's main artery, Ralston Avenue. The private Catholic girls' high school was founded as Notre Dame Academy in 1851 in San José by the Sisters of Notre Dame de Namur, the same order that founded adjacent Notre Dame de Namur University. The school was built to accommodate boarders, but boarding ended in 1972. (Courtesy of Denny Lawhern.)

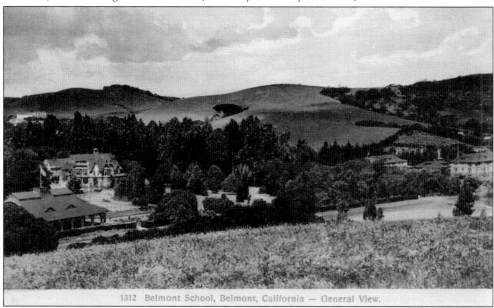

Situated above the southwest corner of Ralston Avenue and Alameda de las Pulgas, the exclusive Belmont School for Boys is pictured on this postcard in an early 1900s view. The buildings shown are, from left to right, the gymnasium, the headmaster's house, and the Senior House. The school was first known as the Reid School; founder William T. Reid, former University of California president, opened the school in the fall of 1885. (Courtesy of Denny Lawhern.)

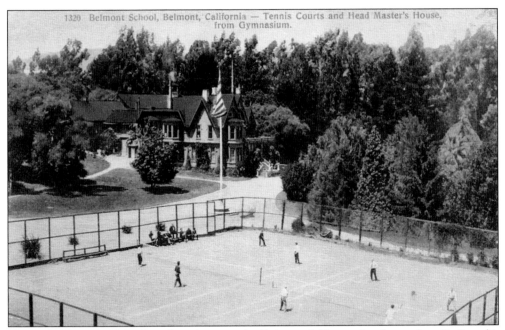

The Belmont School for Boys later became the Belmont Military Academy, then St. Joseph's Military Academy, and now the Immaculate Heart of Mary School. School graduation programs describe Belmont as "a village on the Southern Pacific Railroad, twenty-one miles south of San Francisco." The school considered its location, "a mile and a quarter from the station and beyond the limits of the village of Belmont," an advantage. (Courtesy of Denny Lawhern.)

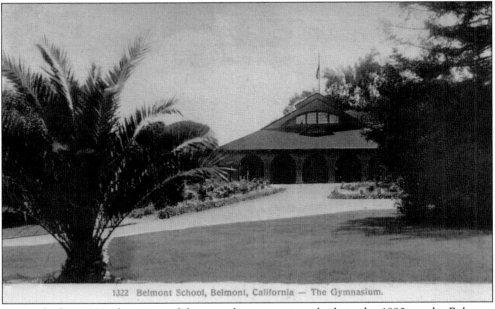

Postmarked in 1909, this postcard features the gymnasium, built in the 1890s as the Belmont School for Boys expanded. The gymnasium was said to have rivaled that of Stanford University, founded a few miles south in Palo Alto in 1891. A "swimming tank," in use until 1976 when it was known as the Belameda Pool, was also added to the campus around the same time. (Courtesy of Denny Lawhern.)

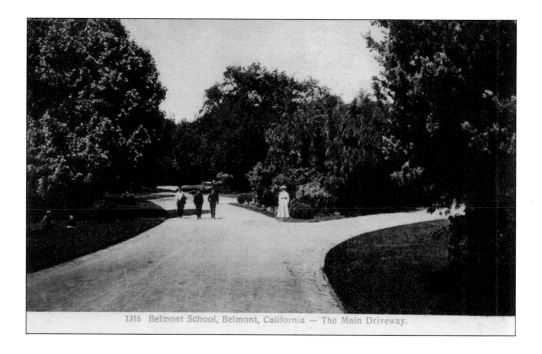

1316 Belmont School, Belmont, California — The Main Driveway.

The postcard above, postmarked on January 18, 1909, shows the main driveway at Belmont School, in operation from 1885 to 1918. The postcard below shows a portion of the same driveway after the school had become St. Joseph's Military School, run by the Sisters of Mercy from 1918 to 1952. This driveway always led to a school, the name of which changed several times: first, the Reid School, then the Belmont School for Boys, and later, St. Joseph's Military Academy. The campus is now Immaculate Heart of Mary School, near the intersection of Ralston Avenue and Alameda de las Pulgas. (Both, courtesy of Denny Lawhern.)

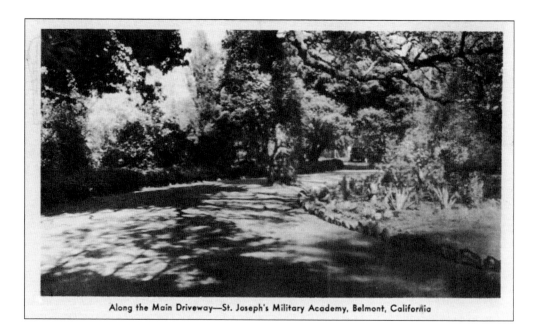

Along the Main Driveway—St. Joseph's Military Academy, Belmont, California

Half a mile from Bay Meadows Race Track, the Belmont Casino at 635 Old County Road was billed as "Le Rendez-vous des Gourmets." From the late 1930s through the early 1960s, host Charles Malaspina's son Tom recalls the Belmont Casino as seating almost 150 people around a dance floor, with a bandstand and two bars, the smaller bar being known as "Charley's corner." Today, the Madison Apartments are located on the site. (Courtesy of Denny Lawhern.)

The Bel-Mateo Motel, so called because of its location on the border with San Mateo at 803 Belmont Avenue, advertised television in its "new deluxe rooms" as well as its proximity "Near Fine Restaurants – Bay Meadows Shopping." When the motel opened in 1954, the postcard boasted about its location "On Main Highway to all Northern and Southern California," or Highway 101, 25 minutes from San Francisco. This motel still operates today. (Courtesy of Denny Lawhern.)

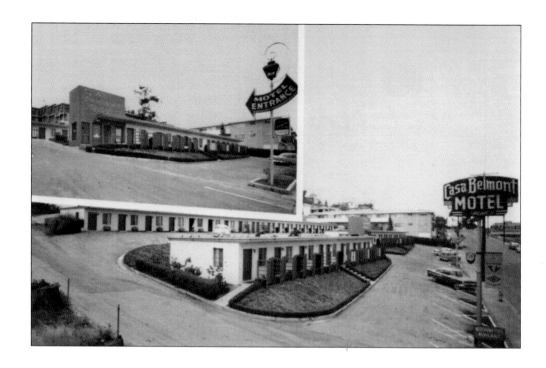

The photographs on these two postcards from the Casa Belmont Motel at 1650 El Camino Real were likely taken about 15 to 20 years apart. The earlier view (above), postmarked in 1951, gives the motel telephone number as LYTELL 3-0091 or LYTELL 3-0092. The later view (below) advertises "Telephone and TV" in each of its 30 units, 15 of them with kitchens, as well as its location on Highway 82 and "Approximately 2 miles from Marine World." From 1968 to 1986, the tourist attraction Marine World/Africa USA was across Highway 101 from Belmont. A Holiday Inn Express now stands on the site of the Casa Belmont Motel. (Both, courtesy of Denny Lawhern.)

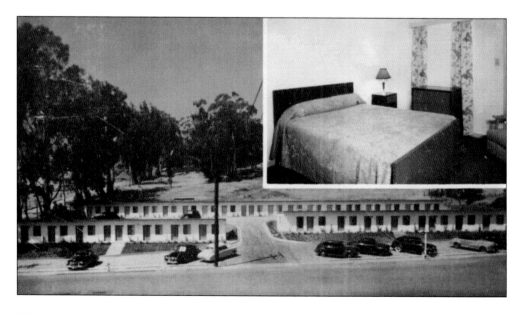

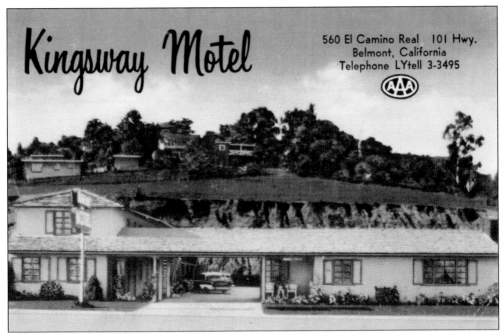

The Kingsway Motel, so named for its address at 560 El Camino Real, which translates from the Spanish as "the Royal Highway," is now known as Hotel Belmont. It still resembles the photograph on this 1950s postcard that described it as "New – Exceptional – Close to good Restaurants." Handwritten notes on the back show prices at $45 a week for "2 people at the end of September." (Courtesy of Denny Lawhern.)

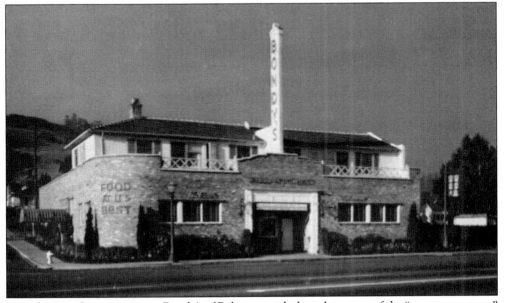

Now the Iron Gate restaurant, Bondy's of Belmont might have been one of the "great restaurants" motel postcards mentioned. The printed message touts Bondy's, with host E.O. "Bondy" Bondeson, as "One of the West's truly outstanding restaurants," 23 miles south of San Francisco on "world-famous El Camino Real" and its "distinctive redwood and flagstone interior, its raised hearth fireplaces, its gracious and attentive service, its attractive lounge and bar." (Courtesy of Denny Lawhern.)

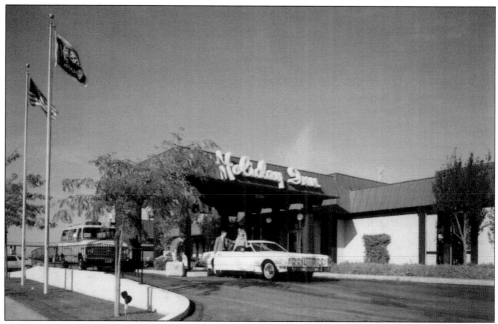

This 1970s postcard notes the old Holiday Inn's proximity to Marine World, accessible from the Ralston Avenue exit off Highway 101. This postcard gives the address for "Belmont-Marine World" as "Highway 101 & Bayshore Frwy., Belmont, CA 94002." Marine World has since moved to Vallejo, California. (Courtesy of Denny Lawhern.)

To reach Marine World, tourists took the Ralston Avenue exit off Highway 101 and drove east toward Redwood Shores, hence Belmont's role as the "Gateway to Marine World," as noted on this postcard. The tourist attraction was built between 1966 and 1968 in bay tidelands. Belmont JayCees built the welcome sign pictured here, and Ralston Hall's entry belonged to College of Notre Dame at the time this photograph was taken. (Courtesy of Denny Lawhern.)

Eight

BELMONT BOOMS
1945 AND ONWARD

During World War II, thousands of people came to the San Francisco Bay Area as part of the war effort. After the war, many of those people stayed. If the world rushed into California during the Gold Rush of 1849, it was stationed here from 1942 to 1946. Developers filed subdivision maps with county planning departments at an alarming rate, creating new neighborhoods and filling in the gaps of open land between small towns around the bay. Belmont's topography rises from the tidelands sooner than most bay towns, so its hills and trees masked the number of new streets and rows of new houses.

Not all this change was unwelcome, however. Belmont had long had a couple of minor red light districts near the bars and rumored bawdy houses along El Camino Real and Old County Road, radiating out from the historic crossroads with Ralston Avenue. In the 1950s, these new homes meant the influx of new families. The Sterling Downs neighborhood replaced the Belmont Airport, and a new school named after longtime Belmont "teaching principal" Mae Nesbit was built on the site of Camp Belmont. And the Homeview neighborhood took over flower fields. Bigger changes were to come, though. The marshes and sloughs where Owen O'Neill had built the landing for his ferry service in the 1860s, where oyster farms had fields, and where ducks hunters' shanties formed a hamlet of their own in the first half of the 20th century were developed into an affluent planned community called Redwood Shores. In 1989, computer software giant Oracle Corp. moved its headquarters into the shimmering towers in Redwood Shores, overlooking a lagoon where college rowing teams now practice.

As development tapered off, preservation efforts increased. When Twin Pines Sanitarium disbanded, a band of Belmonters formed the Save Twins Pines Committee to purchase the 17.5-acre property and its historic buildings. Voters approved their proposed bond in 1972. In 1974, the City of Belmont adopted its first Historic Preservation Ordinance. In 1987, the Belmont Historical Society was formed, and the rest is, as they say, Belmont history.

Belmont grew rapidly in the 25 years after World War II, with its population steadily on the rise: 5,567 in 1950, then 15,996 in 1960, and 23,358 in 1970, with only a slight increase to 25,835 in 2010. This 1948 photograph shows Bayshore Highway at Ralston Avenue before it became Highway 101. The 20 or so shacks along a boardwalk on the O'Neill Slough, known as Shantytown, are visible on the right. (Courtesy of Belmont Historical Society.)

The young men pictured here worked for Morgan Oyster Co., one of the Bay Area's shoal-water oyster-farming companies that maintained sheds around the bay, like this one in Belmont's marshes. The company established a South Belmont bed in 1877 and a North Belmont bed in 1884. The company eventually left Belmont in the late 1940s. (Courtesy of Belmont Historical Society.)

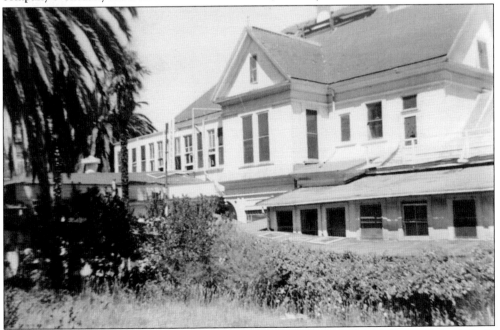

This 1945 photograph shows the rear view of Miramonte, the grand house Caesar Splivalo built in 1888 adjacent to Ralston Avenue, west of Alameda de las Pulgas. Splivalo, known as "the Macaroni King" of San Francisco, was president of Yosemite Flour Mills when he died in 1913. Apartment buildings now stand on the site. (Courtesy of John Shroyer.)

Belmont Public School students gathered in 1948 in front of their school on Waltermire Avenue for their class photograph with their teacher—and a dog. The school was built in 1918 and razed in 1967 over seismic safety concerns. A Safeway grocery store is there now. The district added Louis Barrett School in 1948 and Mae Nesbit School in 1953. Mae Nesbit School is on the site of World War II's Camp Belmont. (Courtesy of Belmont Historical Society.)

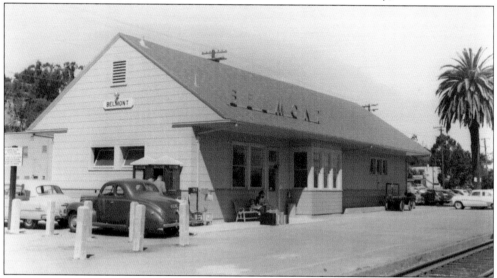

Belmont's train depot, shown in this c. 1950 photograph, sported a sleek, modern look for the increased number of commuters to San Francisco and San José. Other San Mateo County towns, like Hillsborough, Burlingame, and Atherton, eclipsed Belmont as the country home to millionaires, but the "hub of the peninsula" enjoyed a reputation as a comfortable suburb for families. (Courtesy of Belmont Historical Society.)

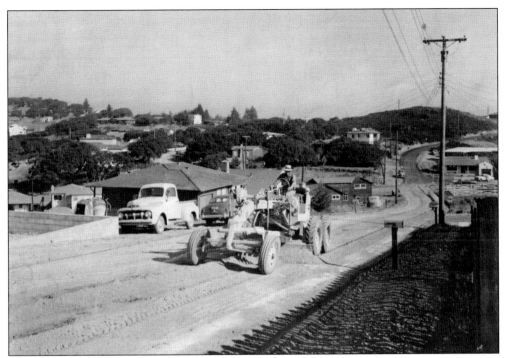

A Caterpillar Diesel No. 212 motor grader prepares the road for oil coating to become Belmont's Read Avenue in this photograph dated September 24, 1952. Construction moved westward into Belmont's hills after World War II. (Photograph by Teen Becksted for Caterpillar Corporation, Peoria, Illinois; courtesy of Belmont Historical Society.)

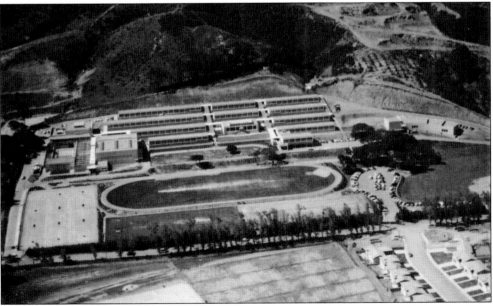

On this postcard, Carlmont High School was described as an "ultra modern public school . . . beautifully situated between the San Carlos and Belmont" when it opened in 1953. This aerial view shows houses lining Chula Vista Drive. The tree-lined street in front of the high school is Alameda de las Pulgas. (Courtesy of Karl Mittelstadt.)

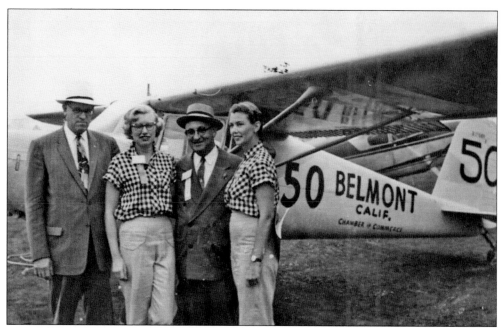

Two unidentified contestants of the 1956 Powder Puff Derby joined Russel A. Estep (left), president of the Belmont Chamber of Commerce, and Charles H. Cook (right), mayor of Belmont, at the San Carlos airport before an airplane race. The 1955 aerial photograph below shows what the pilots must have seen. (Both, courtesy of Belmont Historical Society.)

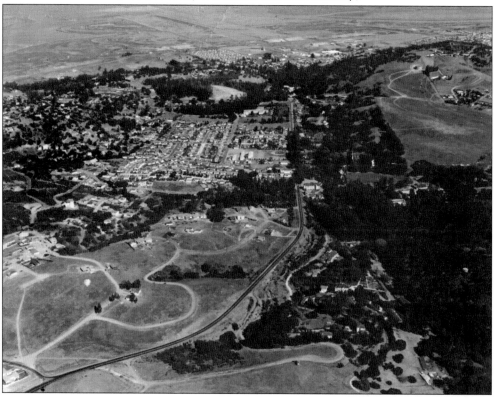

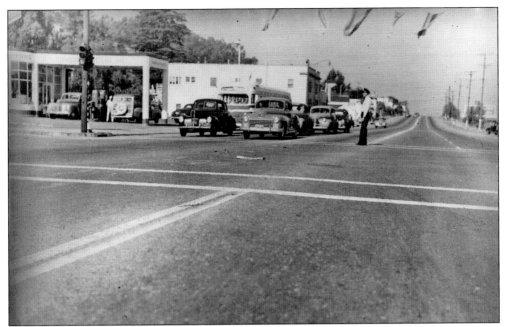

A passing motorist, heading north on El Camino Real, snapped the above photograph at the intersection with Ralston Avenue in the late 1940s. Customers line up for the butcher at the R&S Food Mart at 1888 Ralston Avenue (now a Citibank branch) in the c. 1960 photograph below. Before Carlmont Shopping Center was built across Ralston Avenue in 1955 and before Safeway was built at Alameda de las Pulgas and Ralston Avenue in 1964, the R&S market served as the neighborhood grocer and butcher for western Belmont. (Both, courtesy of Belmont Historical Society.)

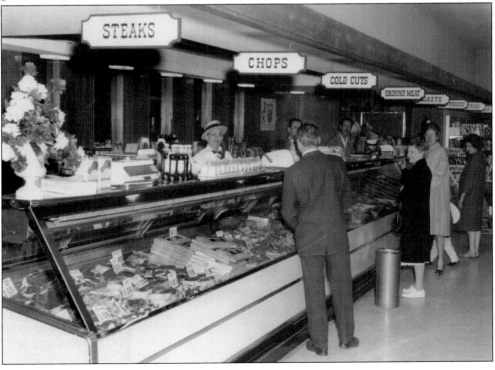

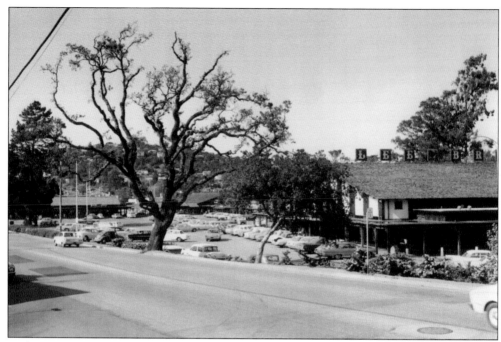

Carlmont Shopping Center, at Ralston Avenue and Alameda de las Pulgas, functions as a downtown area for western Belmont, as the c. 1965 photograph above testifies. The Belmont School for Boys football field was located on the same site in the late 1800s and early 1900s. Famed writer Jack London worked in the school's laundry, and a plaque commemorating his time there stands in the middle of the center above Belmont Creek. On November 28, 1960, the Coast to Coast hardware store suffered a fire, five years after the center was built. (Above, photograph by Newell F. Sharkey, courtesy of Belmont Historical Society; below, courtesy of California Historical Society, *San Francisco Chronicle* Collection, CHS2013.1235.)

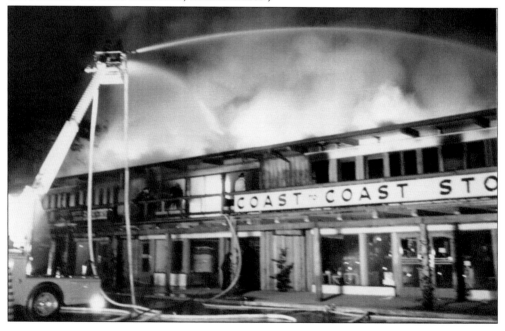

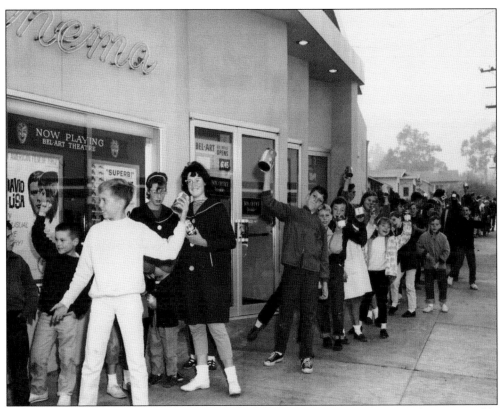

Children line up alongside the Bel-Art Theater at 100 El Camino Real around 1965, possibly for an event called Donation Day, hence the cans of food. The Bel-Art Theater was a converted carpet store next door to the Belmont Theater. (Photograph by Newell F. Sharkey; courtesy of Belmont Historical Society.)

Several unidentified children dress the part of pioneers, declaring "Belmont or Bust" on their wagon. San Carlos–based photographer Newell F. Sharkey recorded many civic events in Belmont and San Carlos during the 1950s and 1960s and also served as a San Carlos city councilman. (Photograph by Newell F. Sharkey; courtesy of Belmont Historical Society.)

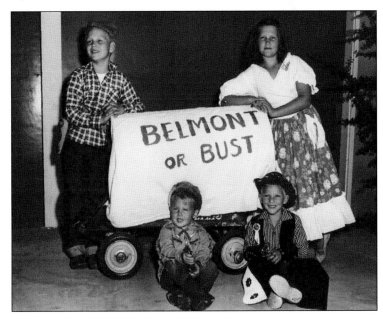

The name of Count Leonetto Cipriani, the man who reconstructed his Italian villa in Belmont in 1853, lives on in his chosen town. The 1962–1963 Cipriani Elementary School basketball team posed for this photograph with its coach. Cipriani Boulevard connects Alameda de las Pulgas and Ralston Avenue in the Belmont hills and crosses the street where Cipriani Elementary School is located. (Photograph by Newell F. Sharkey; courtesy of Belmont Historical Society.)

Mayor Wally Benson, joined by city councilmen and a public official, turned over the first shovel of dirt on a civic project, as recorded in this c. 1960 photograph. Benson served on the city council in the 1950s and early 1960s, when Belmont's population tripled after the development of apartment complexes near Ralston Avenue and Alameda de las Pulgas. (Photograph by Newell F. Sharkey; courtesy of Belmont Historical Society.)

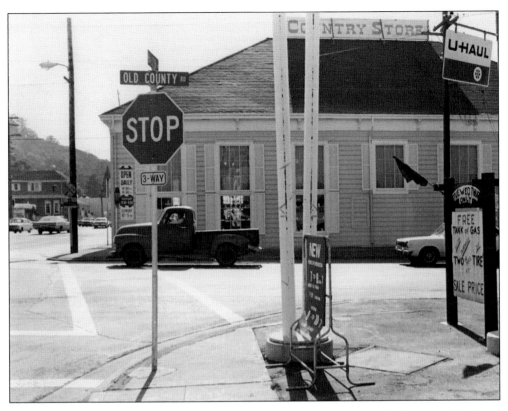

These undated photographs show the old store on the northwest corner of Old County Road and Ralston Avenue as it appeared in the 1960s. The building was torn down when the train track was raised above Ralston Avenue, but not before local preservationists culled the site for artifacts. (Both, courtesy of Belmont Historical Society.)

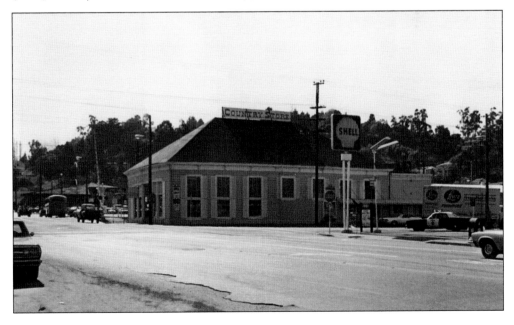

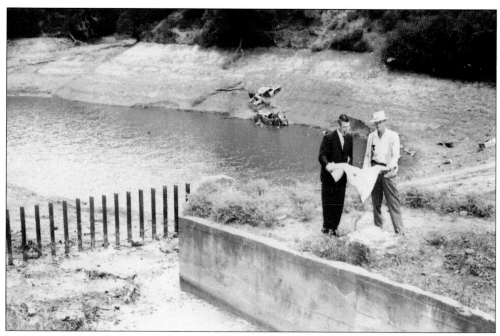

Here, two unidentified men study the plans to dredge Water Dog Lake in the 1960s. Longtime residents recall that San Mateo County pulled abandoned cars out of the canyon with helicopters in the early 1970s. Bank of California founder William Ralston dammed Belmont Creek to form the reservoir for his estate. (Courtesy of Belmont Historical Society.)

Trade your old house for a whole new outlook...

A New Home in
SKYMONT

a prestige address in sunny Belmont.

✓ ✓ ✓

Custom Designed
2–3–4 Bedrooms
Ranch Style · Split Level

✓ ✓ ✓

BUILT BY
WHITECLIFF HOMES

Subdivisions in Belmont moved out of the valley and into the hills in the 1960s. The Plateau-Skymont neighborhood, Belmont's westernmost subdivision, affords sweeping views of Sugarloaf Mountain from a ridgetop north of Ralston Avenue and east of Highway 92. Construction started in 1965. (Courtesy of Denny Lawhern.)

The Warlocks, as the Grateful Dead were initially known, played at The In Room several nights a week for several weeks in the fall of 1965. During this formative time, the band honed their unique sound. The In Room was the lounge of the Chalet Steak Pit restaurant at 635 Old County Road, where the Madison Apartments are now located. (Courtesy of Belmont Historical Society.)

I will appreciate your support November 14th
Shirley Temple Black

Shirley Temple Black

A former child star and America's Depression-era sweetheart, Shirley Temple Black ran her 1967 congressional campaign from her headquarters in Belmont. Her campaign office was located at 950 El Camino Real, close to the Ralston Avenue corner. Black ran as a conservative Republican but lost to liberal Republican Pete McCloskey. (Courtesy of Belmont Historical Society.)

Ed Vallerga, Belmont mayor and city councilman during the 1966–1967, 1970–1971, and 1973–1974 terms, stands directly behind the bucket of a grader (above left, in dark suit) to commemorate the start of a civic project in the now-historic downtown. The 1971 photograph below shows the beginning of construction on Carlmont Woods Apartments at 2515 Carlmont Drive. The area west of Alameda de las Pulgas and south of Ralston—near where the Splivalo home and the Barre ranch were located—is now home to dozens of apartment buildings. (Above, photograph by Newell F. Sharkey, courtesy of Belmont Historical Society; below, unknown photographer, courtesy of John Shroyer.)

For the 20th-anniversary celebration of Twin Pines Park's formation, proponents hung the banner originally strung across Ralston Avenue during the 1972 campaign along one of the park's paths (above). One of the biggest supporters of creating a park on the Twin Pines site was Marine World/ Africa USA, the wildlife park in Belmont from 1968 to 1986. A tiger and its trainer appear for a publicity photograph for the successful 1972 civic effort (below). Twin Pines Park, considered by many to be the gem of Belmont, features 22 acres of woods and trails. (Both, courtesy of Belmont Historical Society.)

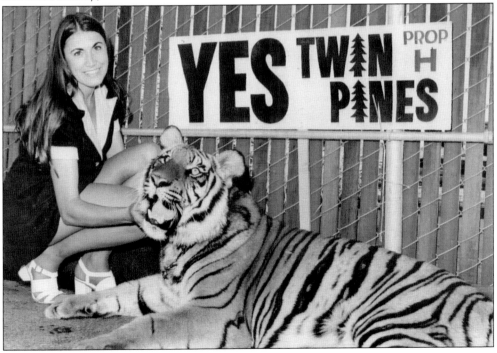

Belmont's "Happy Hydrants" were painted as characters and early American heroes, like the one in the photograph at right, for the nation's 1976 bicentennial celebration. Belmont city clerk Jim McLaughlin is credited with the idea. In 1998, a state senate bill passed unanimously to allow the 400 hydrants to keep their character but be topped off with public safety colors. The Sea Scout station on Island Park, shown in the June 1982 photograph below, was home to the Belmont Sea Scouts, or "Belmonsters." (Both, courtesy of Belmont Historical Society.)

When the Emmett Store was slated for demolition in 1998 for CalTrain station improvements, these men—from left to right, John Shroyer, Jess Jones, Tom Seivert, Matt Hull, Tom Elliott, Jim Williams, Bill Metropoulos, and Denny Lawhern—went underneath the building to look for anything of historical significance. They dug up bottles and other items. In 2004, Belmont Historical Association members gathered in the History Room (below) to greet a delegation from Belmont's sister city of Namur, Belgium. From left to right are Denny Lawhern (Belmont Historical Society president), Jim McLaughlin, Gordon Seely, Hartley Laughead, Ray Keller, Terri Cook, Bob ?, and Hugo Shane. Preservationists continue to expand their museum's collection and to promote interest in Belmont history. (Both, courtesy of Belmont Historical Society.)

BIBLIOGRAPHY

Belburn Village. Real estate promotional booklet. Burlingame, CA: Daley Brothers, Inc., n.d.

Cipriani, Count Leonetto. *California and Overland Diaries of Count Leonetto Cipriani from 1853 through 1871: Containing the Account of His Cattle Drive from Missouri to California in 1853; a Visit with Brigham Young in the Mormon Settlement of Salt Lake City; the Assembling of His Elegant Prefabricated Home in Belmont, the First of Consequence on the San Francisco Peninsula, Later to Become the Ralston Mansion.* Portland, OR: The Champoeg Press, 1962.

Donnelly, Sr. Teresa Augustine. *The History of Notre Dame High School: 1951–1985.* Belmont, CA: Notre Dame Belmont High School, 1985.

Estep, Russel. *A History of Belmont.* Burlingame, CA: Fuchs Publications, 1981–1989.

Fosburg, Lorna Ruth with Harmeet K. Bhatia. *Lorna Ruth: My Life.* San Mateo, CA: WesternBook/ Journal Press, 1993.

Graves, J.A. *My Seventy Years in California: 1857–1927.* Los Angeles: The Times-Mirror Press, 1928.

Hand-Book and Directory of Santa Clara, San Benito, Santa Cruz, Monterey and San Mateo Counties. San Francisco: Commercial Steam Presses, 1875.

Lavender, David. *Nothing Seemed Impossible: William Ralston and Early San Francisco.* Palo Alto: American West Publishing Company, 1975.

Lyman, George D. *Ralston's Ring: California Plunders the Comstock Lode.* New York: Charles Scribner's Sons, 1947.

MacCrisken, Ria Elena. *Heritage of the Wooded Hills: A Belmont History.* Belmont, CA: Wadsworth Publishing Company, 1977.

A Member of the Congregation. *In Harvest Fields by Sunset Shores: The Work of the Sisters of Notre Dame of the Pacific Coast, Diamond Jubilee Edition: 1851–1926.* San Francisco: Gilmartin Company, 1926.

Meriwether, Nicholas. Grateful Dead archivist, University of California, Santa Cruz. E-mail and phone interviews, July and August 2013.

Pacific Telegraph & Telephone Company. *San Mateo County Telephone Directory, November 1929.* San Francisco: Pacific Telegraph & Telephone Company, 1929.

San Francisco Call. "Ralston's Belmont Palace will become a madhouse." August 24, 1900.

W.T. Reid Foundation. *Belmont School for Boys Catalogue for 1915–1916.* San Francisco: C.A. Murdock & Co. Printers, 1915.

ABOUT THE ORGANIZATION

Most of the photographs in this book were generously provided by the Belmont Historical Society, founded in 1987 and housed in the historic George Center house in Twin Pines Park. Denny Lawhern is president and historian.

DISCOVER THOUSANDS OF LOCAL HISTORY BOOKS
FEATURING MILLIONS OF VINTAGE IMAGES

Arcadia Publishing, the leading local history publisher in the United States, is committed to making history accessible and meaningful through publishing books that celebrate and preserve the heritage of America's people and places.

Find more books like this at
www.arcadiapublishing.com

Search for your hometown history, your old stomping grounds, and even your favorite sports team.

Consistent with our mission to preserve histo͏ local level, this book was printed in South Carolina or ͏rican-made paper and manufactured entirely in the United States. Products carrying the accredited Forest Stewardship Council (FSC) label are printed on 100 percent FSC-certified paper.

MADE IN THE USA